RENDERING WITH MARKERS

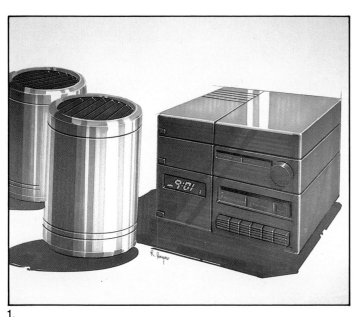

1.

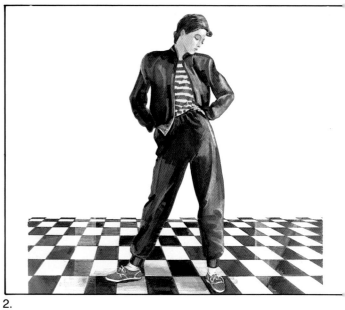

2.

RENDERING
WITH
MARKERS

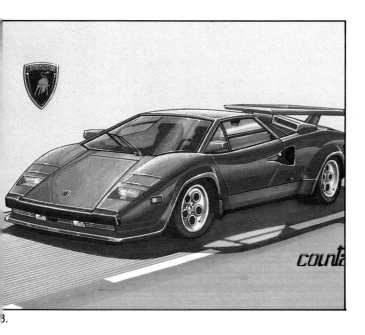

B.

BY RONALD B. KEMNITZER

WATSON-GUPTILL PUBLICATIONS/NEW YORK

To Linda

Note: All renderings in this book are
by the author unless otherwise
indicated.

Title page:
1. Rendering by Ron Hayes
2. Rendering by Nancy O'Connell
3. Rendering by Charles P. Klasen,
 Klasen Design Associates

Copyright © 1983, 1988 by Ronald B. Kemnitzer.

First published 1983 in New York by Watson-Guptill Publications,
a division of Billboard Publications, Inc.,
1515 Broadway, New York, N.Y. 10036

Library of Congress Cataloging in Publication Data

Kemnitzer, Ronald B.
 Rendering with markers.

 Includes index.
 1. Dry marker drawing—Technique. 2. Felt marker
drawing—Technique. I. Title.
NC878.K45 1983 741.2'6 83-10499
ISBN 0-8230-4533-1
ISBN 0-8230-4532-3 (pbk.)

**Distributed in the United Kingdom by Phaidon Press Ltd., Littlegate
House, St. Ebbe's St., Oxford**

Manufactured in Japan

13 14 15 16 17 18/05 04 03 02 01 00

ACKNOWLEDGMENTS

The writing of a book requires the cooperation and assistance of many people. I owe a great debt of gratitude to the following who helped in the completion of this book:

To my family who gave me their full support and the time necessary to complete this project.

To my students while I taught at Michigan State University who first encouraged me to write this book.

To my students while I taught at the University of Cincinnati and the Kansas City Art Institute who contributed so much work to the book.

To the many friends and colleagues in the design profession who contributed advice, encouragement, and renderings. Special thanks to Gil Born.

To David Lewis, Mary Suffudy, and Candy Raney of Watson-Guptill Publications for their advice, encouragement, and support. Special thanks to Mary for her critical comments and guidance during the writing of the text.

To Norm Steinkamp who took the time to teach me all he knew about marker renderings and fishing.

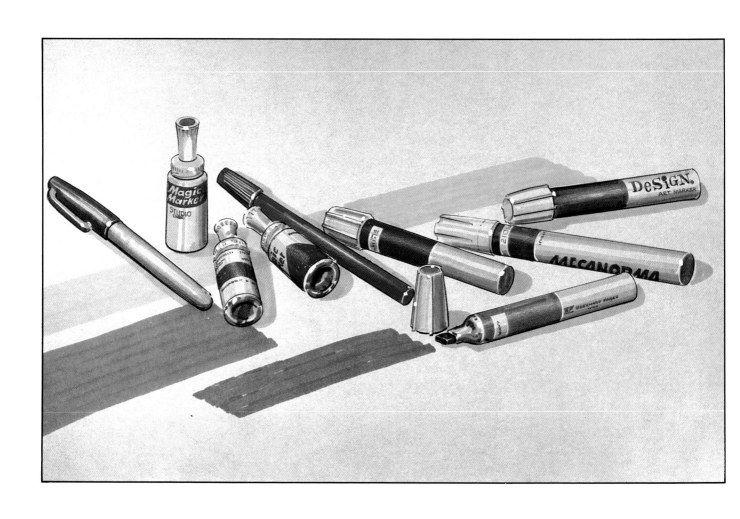

CONTENTS

INTRODUCTION

4.

Rendering by Gil Born

5.

7.

Rendering by Charles Klasen

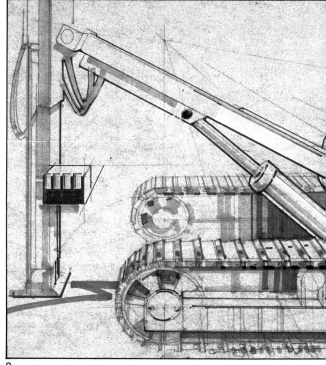

8.

4. *Interior designers* use markers to illustrate design concepts to their clients.

5. *Architects and landscape architects* use markers for conceptual sketching and building elevation studies.

6. *Studio artists* use markers to develop concepts rapidly and economically.

7. *Illustrators* rely on markers for their versatility and pure, vibrant color.

8. *Product designers* use markers for the rapid development of concepts through quick marker sketches.

Rendering by Kemnitzer, Reid, and Haffler, Architects

The Corporate Design Center, Inc., David Tompkins

6.

Rendering by Tim Carr

Who uses markers? In light of the remarkable acceptance of markers into our everyday life since their introduction in recent years, the question might more appropriately be—who doesn't use markers? From preschool children who use them for drawing on everything, to students who use them for highlighting textbooks, to illustrators who use them for extremely detailed renderings, markers are without doubt one of the most familiar and widely used of all art materials. In the professional world, markers are used extensively by studio artists, product designers, illustrators, architects, and interior designers. They are popular among these professional groups because of their immediacy, the extensive selection of available colors, and their compatibility with other materials. The overwhelming reason for the frequent use of markers in professional studios is that they facilitate quick sketching and rendering. Because sketches and renderings can be executed in marker faster than in other media and because the results are at least as good and often better, marker renderings are economical and help to keep the design process moving at an efficient pace. A greater number of design concepts can be communicated to the design team and client and presumably more informed, thoughtful and exciting design decisions result.

Considering the extent to which markers have become a part of our everyday lives, there has been surprisingly little available to users in the way of instructional materials. The use of markers for rendering has increased steadily and rapidly since their introduction and has evolved into a medium of distinctive yet diverse techniques. This book was written in response to the glaring need for instructional and reference material, as well as to document the stylistic techniques that have evolved as a result of extensive professional use and experimentation.

CHAPTER 1
TECHNIQUES OF VISUAL ILLUSION

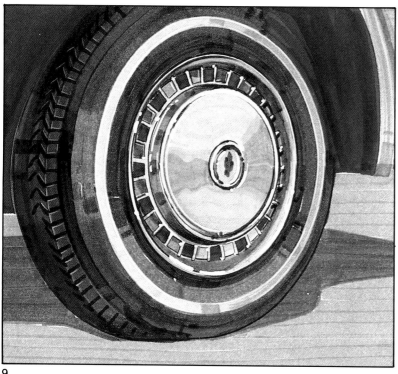

9.

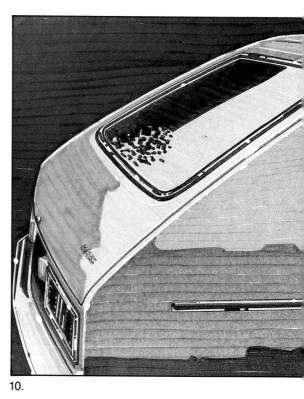

10.

9, 10, 11. Value distribution is an important concern when rendering with markers. Note that the value range in the dirty hubcap (figure 9) is small and falls in the middle of the value scale. Compare it to the shiny, clean hubcap (figure 11), where the values are exaggerated and at the extreme ends of the value scale. In figure 10, the illusion of gradated values is achieved by dividing the automobile into several "zones" of value.

Markers are a unique graphic material. They apply color to paper in a very direct and immediate manner. They are convenient in that they require no preparation and no clean-up, as do brushed-on art materials. They are also unforgiving in that once the marker is applied to paper, the color can't be removed and the degree to which it can be manipulated is restricted. Some have compared marker renderings to the paint-by-number technique and as painful as that analogy is to me as a "serious" designer, there is an element of truth to it. I prefer, however, to make what may be considered by many as an equally clumsy comparison. I consider good marker renderings to be somewhat "impressionistic." That is to say that they should express a quality of light that gives them visual interest and excitement. Many of the renderings found in this chapter exhibit an impressionistic quality, and they do so, not because of where the marker was applied, but because of where the marker *wasn't* applied. Novice marker renderers make an all too common mistake of overworking their renderings. They fill in every conceivable area with solid fields of color, often several coats of different colors. I attribute part of this to nervousness with a new media, part to the excitement generated by touching marker to paper, but most of all because of a lack of understanding and sensitivity as to how to adjust visual reality to accommodate the unique qualities of markers. What could result with this understanding is a strengthened ability to create the illusion of reality. To help nurture this understanding, this chapter will explain the perceptual adjustments most important for successful marker rendering. Photographs of scenes and objects are accompanied with corresponding marker renderings. As you study these photographs and renderings, ask yourself, which is more appealing—reality or illusion?

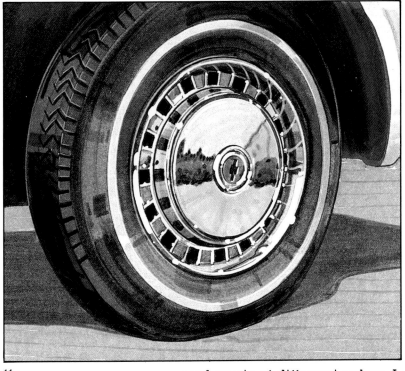

11.

12A.

Controlling the View

12A, B. Novice marker renderers seem to feel a compelling need to fill the entire page with color. It isn't necessary from an illustrative point of view and often serves to confuse and distract the viewer. By controlling the amount of material illustrated and the view of that material, the renderer has more influence on how that material is perceived. This rendering creates a visual focus on the entrance of this house that is stronger than that of the photograph. The house seems to dissolve toward the edge of the paper, which helps to focus attention on the door and also helps to lighten up the scene. Note that in this rendering there are quite a few areas in which no marker is applied. All of the shading in this rendering was accomplished with marker. Colored pencil was used to define the mortar joints and other lines.

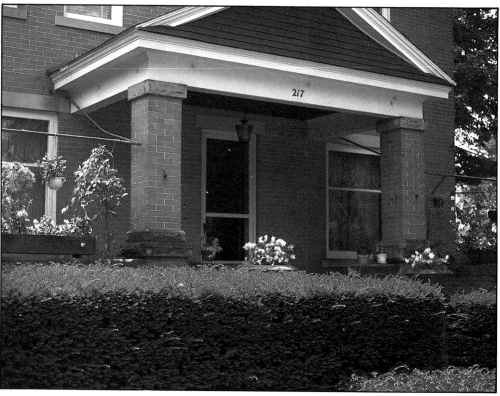

12B.

Enhancement of Light

13A, B. When lighting conditions are strong enough to create an interesting array of values in reality, subtle details are often eliminated or obscured. An example in this photograph is the nearly unidentifiable display area that is clearly defined in the accompanying marker rendering. Note, however, that the values of the shell of the calculator are very similar in both the photograph and rendering. This is an example of how light conditions must sometimes be changed *within* a scene or object illustration. If such an arbitrary manipulation of light is necessary to clearly delineate an object or scene, do it. I have on occasion even changed the apparent light direction several times within a rendering because it helped to more clearly define several important details in the rendering.

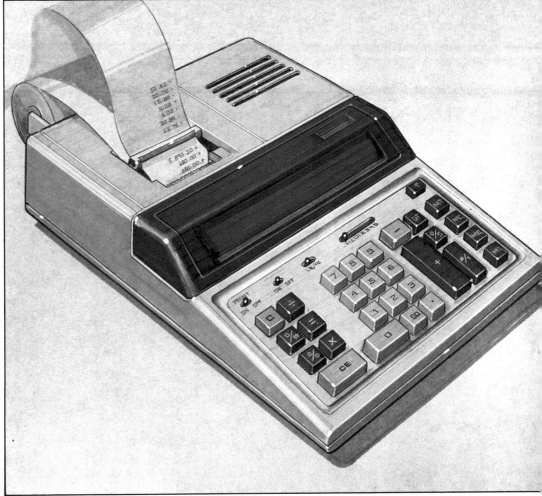

13A.

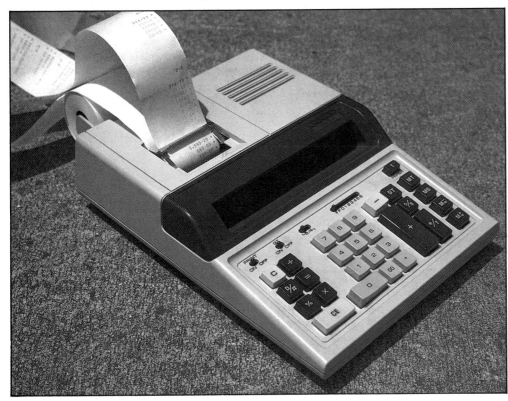

13B.

Developing a Value Range

14A, B. To clearly define a form, it is best to depict that form with a complete range of values. With unusually high or low level lighting conditions this is difficult. Objects of predominantly one color, such as this building, also pose problems to the renderer, particularly when the colors are black or white. In order to clearly define the building, I have exaggerated the value range that exists in the photograph, where the surfaces of the building most perpendicular to the line of view are all the same value. This is as it should be because these surfaces are in identical positions relative to the light source. While physically accurate, this scheme of value distribution does not dramatically or effectively define the form of the building, and there are times when the physical rules of value distribution are violated for the sake of visual clarity.

In the rendering, I have arbitrarily lightened the value of the surface closest to the viewer in order to make it appear to advance in space. This effect is further enhanced with the arbitrary dark stroke of value to the left of this surface. This manipulation of value not only enhances the form of the building but also permits a clearer definition of window details because of the increased range of values. The available range of values in marker color is limited, so the successful marker renderer must make intelligent decisions about value distribution and be prepared to violate the conventional rules of light.

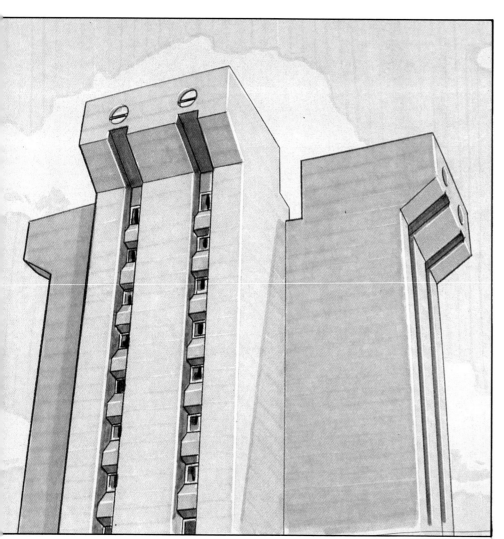

14A.

14B.

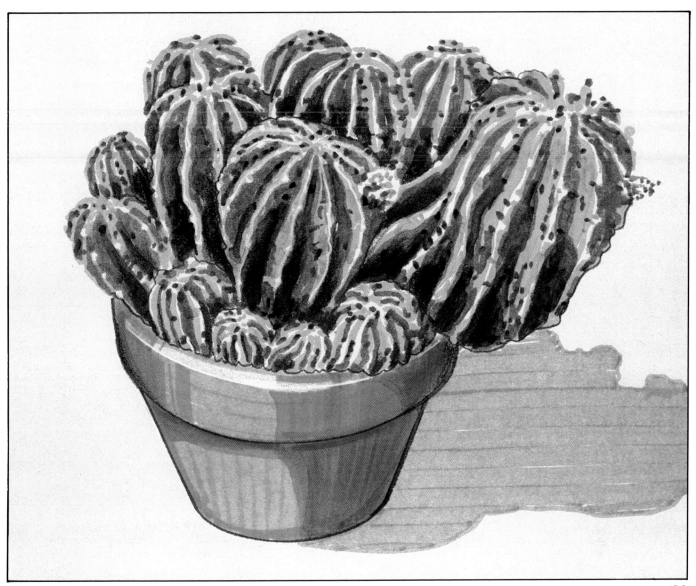

Zoning Values

15A, B. Because markers are a very immediate medium that offers limited opportunity to blend and manipulate value, gradated distribution of values is extremely difficult. To create the illusion of a surface that gradually changes from light to dark, it is necessary to depict the surface with several steps of value gradation, each defining an area of the surface. This rendering of a cactus plant illustrates this principle, although the values of both the plant and pot have been "zoned" with some additional marker enrichment of the cactus for textural effect. Basically, however, the form of the cactus plant is defined with zones of green in a four-step range of values. The pot is treated in a similar manner. Note that there is a great deal of white paper that is allowed to remain between zones of value in the cactus and on the rim of the pot. When rendering objects that are continuously toned from light to dark, it is very helpful for marker renderers to consider how these values might be zoned in a way that not only defines the form but facilitates the sense of light reacting with the surface of the object. You'll find that these techniques are most effective if you work out the zones of value with very quick, rough sketches before proceeding with the final marker rendering. Such a practice will also give you additional confidence in what you are doing and allow you to concentrate on marker application.

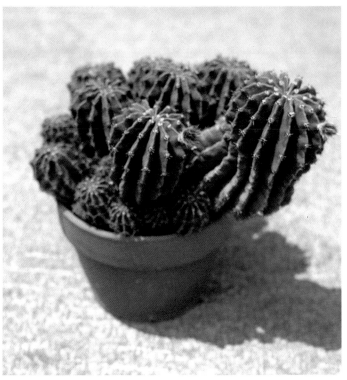

15B.

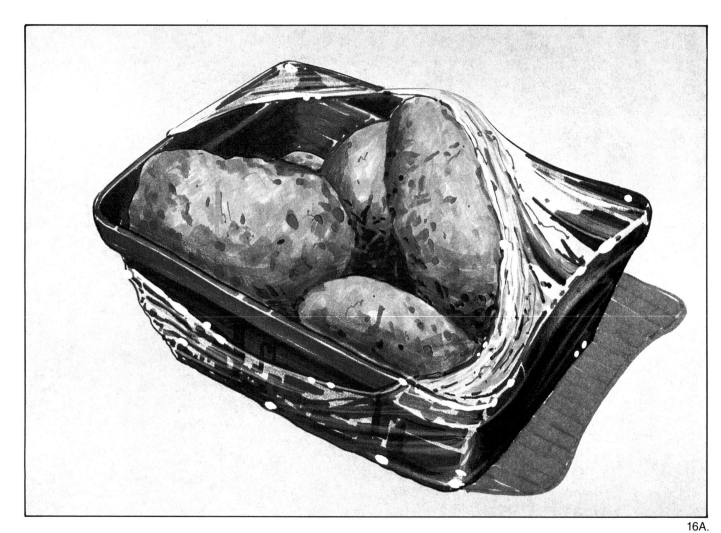

16A.

Definition of Materials

16A, B. When defining specific materials, marker renderers must identify the main characteristics of that material and exaggerate those qualities. Marker rendering relies on exaggeration to be informative and exciting. In the case of this torn package of potatoes, the exaggeration of material qualities is evident: the texture and variegated color of the potatoes are depicted in a bolder fashion than reality. The principal visual qualities of the cellophane shrink-wrap are the elongation of reflections and the glossy surface. These qualities are greatly exaggerated and obscure much more of the potatoes and paper tray than in reality. This technique is not only effective in depicting the character of the material, but also allows the use of white areas to brighten and energize the rendering visually. (Chapter 7 reviews the salient visual qualities of a number of materials and demonstrates techniques for depicting them.) As you look at objects, scenes, and materials in your everyday activities, look at them with a critical eye and try to determine what the visual essence of that material is. Then, try to mentally visualize what it would look like if rendered with markers.

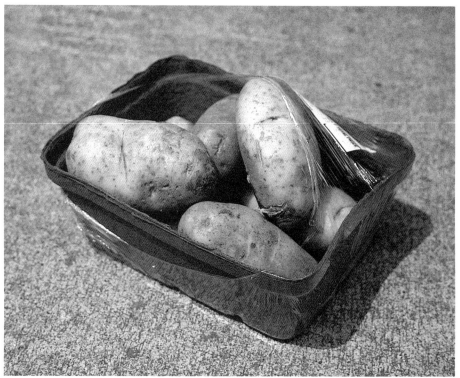

16B.

Enrichment of Surface

17A, B. This rendering of cans, lids, and a pail is rather straightforward in terms of light qualities and value distribution. The photograph attests to the fact that this was not a particularly interesting visual encounter. The surfaces are rather dull and the movement of light throughout the scene is unexciting. The rendering, however, has been dramatically enriched by adding reflections, light movement, and textural qualities that don't exist in the visual reality of the scene. The prime example of surface enrichment in this rendering is the treatment of the pail. The bands of color and value that define the form were also strategically situated to create some visual activity and excitement. As long as this type of enrichment does not assume the symmetry of an applied pattern, it won't look like a multi-colored pail but will become an *interesting* one-color pail. The metal trash can has been enriched with reflections and stronger shadows in the recesses of the fluting. The plastic tubs and lids have also been enriched with subtle reflections that aren't there in reality. All of these reflections were added lightly with a very loose, freely moving hand. Novice marker renderers are usually too heavyhanded and nervous to create reflections that are believable. My advice to these people is to *relax*, practice, and learn to allow some emotion to become a part of the rendering process. It will show!

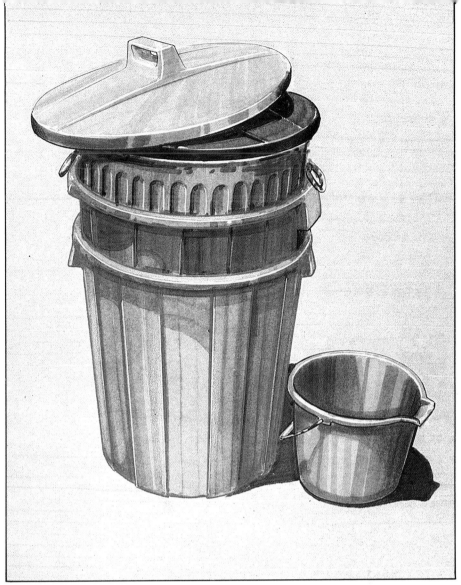

17A.

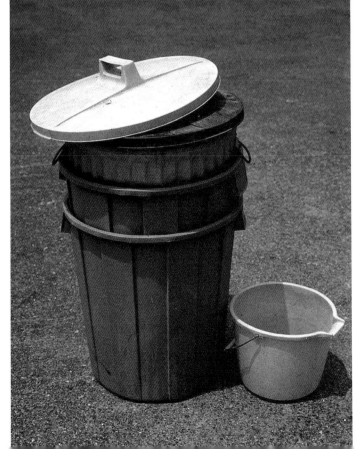

17B.

CHAPTER 2

MATERIALS

18.

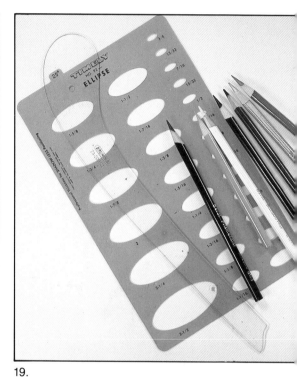

19.

18, 19, 20. Markers are available in hundreds of different colors, sizes, and shapes. Most marker illustrators also incorporate various other media, such as colored pencils, pastels, spray paints, and inks. These supplementary materials combined with markers offer the renderer a wide range of stylistic options.

When markers were first introduced, there were very few colors from which to choose, and they were very intense, basic colors that were not conducive to any of the subtleties of blending described in this book. Fortunately for marker renderers, competition among manufacturers has provided artists with an overwhelming number of colors. The selection of hues is so diverse as to make available colors suitable for nearly every rendering purpose. There are even many fluorescent and metallic-colored markers now on the market. Markers that match standard printing ink colors are also available, as well as colors that accurately depict a wide range of materials. Many markers that were once available in only one value of one saturation level now come in a complete value range as well as in a number of intensities. For renderers, the choices are indeed pleasant!

The range of marker sizes has also increased dramatically. Not long ago markers were available in only one body size and tip configuration; there is now a plethora of sizes and configurations, ranging from the round, elongated bodies of the fine-tipped markers to the flat, shortened bodies of the extra-wide-tipped markers. Paper manufacturers have also responded to the popularity of markers by developing and marketing a wide selection of papers that enhance and extend the graphic qualities of markers. These advances in materials have helped greatly in the maturation of marker rendering into a legitimate, popular, and exciting visual medium.

This chapter examines the materials available to marker renderers, including the various collateral media that artists use in combination with markers, such as colored pencils, pastels, spray paints, and inks; the physical characteristics of markers; and the care and selection of the various kinds of markers. In addition, the physical qualities of several popular marker papers are described, and comparisons are made between the effects of these papers on identical rendering techniques.

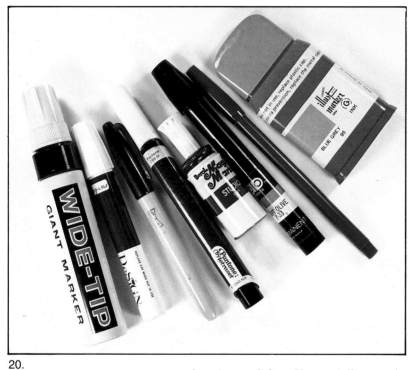

20.

Markers

21. Markers are available with solvent-based inks (permanent markers) and water-based inks (watercolor markers). The techniques described in this book are applicable to permanent markers.

The marker tip is the part of the tool that makes contact with the paper and produces the image. The tip is made of felt and is in direct contact with the large ink-impregnated piece of felt within the marker body. The ink moves through the felt and is absorbed by the paper, creating a colored "stain." The most popular and widely used marker tip configuration is the broad-tipped marker, such as the one pictured second from the top. This size marker is available in many more colors than any of the other sizes pictured. The super-wide-tipped marker pictured at the top is available in a very limited range of colors and is more of a novelty item than a utilitarian illustration tool. Fine-tipped markers such as the bottom three pictured here are very useful in marker illustration for line and texture enrichment as well as for applying color to very small areas. They are available in a wide range of configurations and in a number of colors, but the color range is not as great as the broad-tipped type.

Note: When you work with permanent markers, you should take the normal safety precautions that every well-informed artist takes in the studio with whatever medium he or she works in. *Always* make sure your work area has proper ventilation. The best way to insure that solvent fumes go out the window and not into your lungs is to put your worktable in front of a window in which an exhaust fan has been placed to draw off the fumes. Also, it is important to remember to cap each marker after use; don't leave several markers open at the same time.

In general, avoid getting colors and solvents on your skin. Never eat, drink, or smoke in the studio; colors and solvents have a way of getting on your sandwich, coffee cup, or cigarette and then into your mouth. Finally, at the end of the workday, make sure that all your markers—and all other containers—are tightly capped.

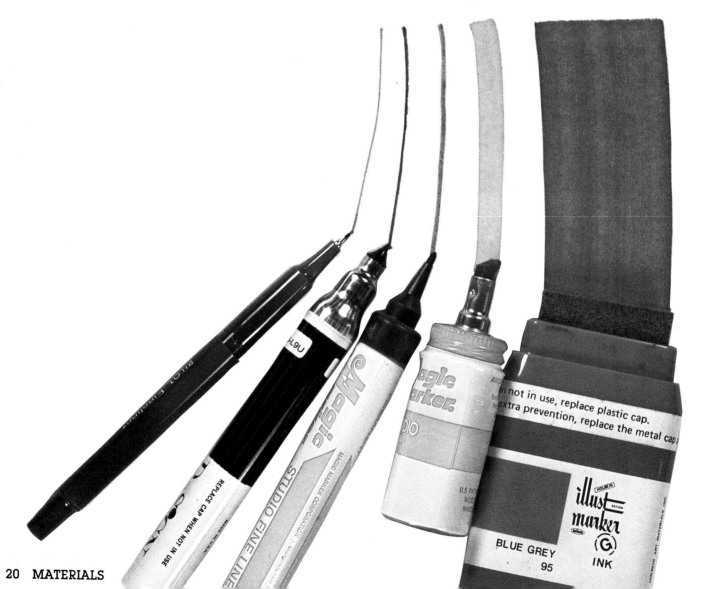

22.

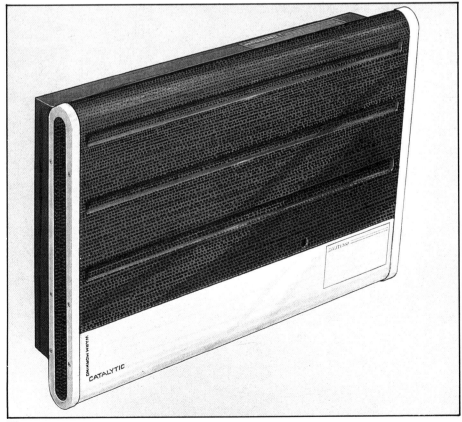

23.

22. This marker illustration incorporates the use of several sizes of markers. Broad-tipped markers were used to delineate the larger areas of the illustration. Fine-tipped markers were used to delineate smaller areas, such as the books and the plant on the right. Fine-tipped markers were also used to delineate small details such as the wood grain and to enrich the fabric objects with texture.

23. In this marker illustration, broad-tipped markers were used for everything but the delineation of the perforations of the heater. A blunt-pointed "Sharpie" marker was used to define each perforation and create a dramatic textural illusion.

Purchasing Markers and Selecting Colors

24. Marker color is indicated by a name, coded number, colored cap, or some combination of these codes. The only reliable method of determining the color of a marker is to test it. A marker that is "fresh" will make clean, evenly gradated marks such as illustrated here. There should be no change in color or value within a single stroke or a small field of color made up of five or six strokes. The marker should require very little pressure to make an even mark, and the ink should be readily drawn from the marker tip by the paper. Markers that require strong pressure to make a clean mark and markers that squeak when used are partially dried out. Unless you purposefully want a marker that slowly releases its ink and produces a streaked mark, the purchase of a dried-out marker is a mistake.

24.

25, 26. To help you select appropriate marker colors, manufacturers provide visual aids such as color charts. Although they are very helpful in identifying potential additions to your color palette, the final decision should be made by testing the marker. While the color charts come close in matching the marker colors, printing limitations prevent totally accurate representation. In addition, the paper that you use will affect the marker color. Figure 26 illustrates swatches of marker color on these different types of paper and compares them with their corresponding swatches on the manufacturers' color chart. The second color from the bottom most dramatically illustrates the variation that can occur not only between the color chart and the marker color, but the difference in color resulting from paper selection. If your color requirements are especially critical, you will want to check marker condition and color as well as its effect on the paper you will be using before making a final selection.

25.

26.

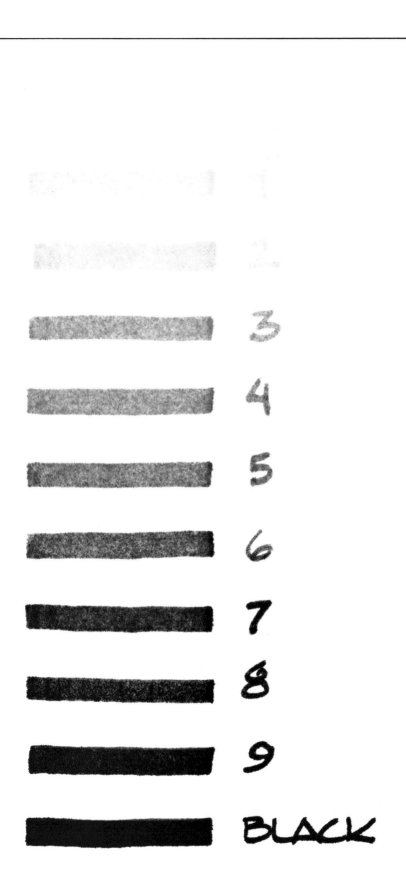

27.

Gray Markers

27. Gray markers are very useful when illustrating objects that are white or black, adding surface shadows to objects and in some cases for altering the value of other colors. Gray markers are available in warm and cool tints and in value ranges from 1 (almost white) to 9 (almost black). The cool grays illustrated here have a slight blue tint to them. Warm grays have a slight brown tint to them. Not all marker manufacturers make a complete range of gray values and among those that do, even fewer produce a range that has consistent coloration and equally spaced gradations in value. The markers used for this illustration are the Magic Marker brand, and I think they come as close as any currently available in meeting high standards of consistency. When you select a range of gray markers for an illustration, be sure that the color tint doesn't vary exceedingly from one marker to the other and that the value range is compatible with the technique of shading that you will be using.

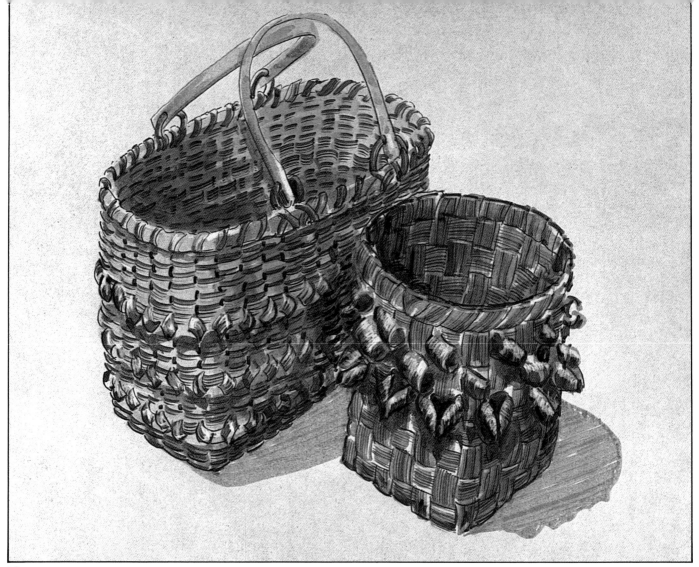

28.

Using Dried-Out Markers

28. Eventually, all markers will dry out, regardless of how securely the cap is attached. Such markers produce an unevenly colored, streaked mark that is unsuitable for most types of illustration. Don't despair and don't discard them immediately, as they may still be useful for certain visual effects or may be "rejuvenated."

29. This illustration of handwoven baskets was created using the same dried-out marker illustrated below. Because of the distinctive textural quality of the mark produced, this dry marker was an appropriate choice for depicting the surface quality of the basket. A light tan marker in good condition was used to shade the baskets and enhance the dimensional effect of the illustration, and a cool gray marker in good condition was used for the shadows. Fine-tipped brown markers and colored pencils were used to define the edges of the basket. If you need a "dry" marker for a particular illustration, but have only nice, fresh, wet ones, you can temporarily dry one out by removing the cap and letting the tip remain exposed to the air for about five minutes. This will cause the solvent-based ink in the tip to evaporate faster than it can be drawn up from the interior reservoir. As soon as you are through using the marker, immediately secure the cap to it. After about half an hour, the solvent will have worked its way to the tip. A few strokes on scrap paper with each side of the marker tip should get the ink flowing smoothly again. More pressure on the marker than usual may be required to restore the flow of the ink. Your marker will now work as it did before the drying out began.

29.

30.

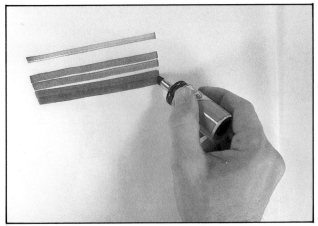

31.

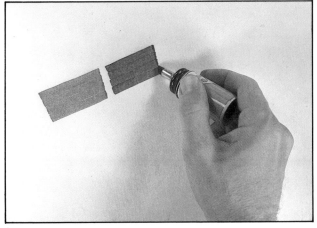

32.

Rejuvenating Dried-Out Markers

30, 31. Markers that are dried out can be restored with partial success by replenishing the felt reservoir with solvent. Standard over-the-counter lighter fluid is acceptable for this purpose. For those markers with screw-on tips, simply unscrew the cap and let four to six drops of fluid drip onto the felt in the reservoir body. Attach the cap securely and allow the fluid time to permeate the felt before rubbing the marker tip on a piece of scrap paper to draw the ink into the tip. For those markers with permanently sealed reservoirs, the solvent must be injected into the reservoir-body felt with a syringe. Do not apply solvent to the marker tip, as it will not work its way into the reservoir where the ink is and will instead produce a very diluted and unevenly colored mark before quickly returning to a dried-out state. A properly rejuvenated marker will produce strokes of color with consistent coloration and value. Figure 31 compares the marks of a rejuvenated marker with the dried-out stroke it created earlier. Markers can be rejuvenated once or twice, depending on the amount of ink pigment remaining in the felt and the overall condition of the marker. Markers that have been rejuvenated once too often or have had too much solvent added will create a "soggy" mark that bleeds profusely, is very slow to dry, and will have uneven coloration. If you find that a marker exhibits these qualities when you are testing them for purchase, do not buy them as they are probably the result of a clumsy rejuvenation attempt and will not have a very long and useful life.

32. Because of the difference in chemical formulations of the manufacturer's solvent and lighter fluid and their proportions to ink pigment suspended in the felt, even the best of rejuvenation attempts will affect the color of the marker involved. Compared in this illustration are the marks of the rejuvenated marker on the right and a new marker of the same color on the left. Clearly, they are not the same. Rejuvenation will invariably affect the color and/or value of the marker. This shift in color and value will vary from color to color. Be aware of the changes that occur when you rejuvenate your markers and don't expect these colors to be the same as when they were new.

Cleaning Markers

33. Because of the solvent base of the inks, marker tips can pick up colors as well as dispense them. This can create a problem when using a marker color as an overcoat on another color. The tip of the second color will dissolve and absorb small amounts of the first. Markers also pick up colored pencil lines, pastel, and any grease spots that may be on the paper surface. When you encounter any of these situations, the marker should be thoroughly cleaned before replacing the cap. The top stroke of this illustration was made using a dirty marker. To clean it, the marker tip was moved over the surface of a piece of scrap paper with more pressure than usual and in a number of directions so that all surfaces of the tip came in contact with the paper. This scrubbing action draws the deviant color from the marker tip. Once the original color flows from all surfaces of the tip with no contamination, the marker is clean and the cap should be immediately secured in place. Always clean the tip of your markers *before* attaching the cap and always check the marker condition and color on a piece of scrap paper before using it. Few things are as discouraging as applying the last stroke to a beautiful marker illustration with a contaminated marker.

33.

Making Your Own Markers

34, 35, 36. There are occasions when a special-sized marker or a custom color is required. Such circumstances can be accommodated by making your own markers. To do so, use a common artist's clamp and absorbent, lint-free cotton pads. The pad pictured is a "litho pad," which is used to clean printing presses and is available in well-equipped art stores and in most printing supply stores. If you are desperate for a substitute material, the filler material in sanitary napkin pads is nearly identical. Fold the cotton pad to the exact width of the desired mark and secure it with the artist's clamp. The flexibility and sponginess of the tip can be controlled by varying the number of thicknesses of material and the distance it protrudes from the clamp. Add ink to the cotton material and allow it to soak in. It can be evenly distributed throughout the pad by rubbing it on a piece of scrap paper. (Wax paper works well as it doesn't extract the ink.) The ink can be thinned with lighter fluid if necessary. Custom colors can be mixed using standard solvent-based inks. The marker color is then applied to the paper. There is no effective way to seal and preserve these homemade markers for future use, so the ink-impregnated pad is discarded immediately after use.

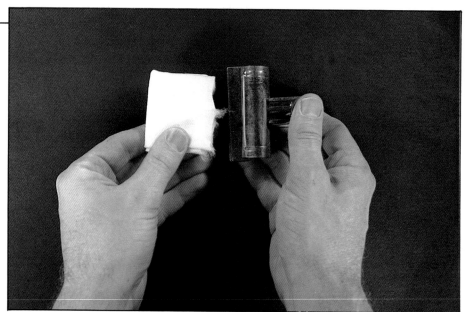

34.

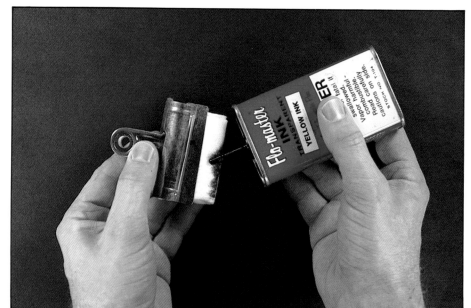

35.

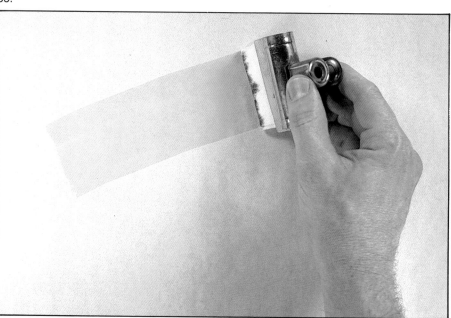

36.

37.

37, 38. A "rainbow" effect can be created by mixing two or more colors on a single cotton pad. Here red and black inks are combined in a homemade marker to produce an interesting multicolored background for another marker sketch that is cut out and applied to the background.

38.

Papers

39. Many paper manufacturers produce papers made specifically for marker illustration. These are widely distributed and readily available. There are also a number of papers and illustration boards that are not produced specifically for markers but are nonetheless useful for exciting marker illustrations. Marker papers have three physical qualities that have a great effect on the techniques described in this book. These qualities are translucency, ink-absorption rate/capacity, and surface tooth. No two paper types are exactly alike in terms of these qualities, and this fact is a boon to illustrators. By selecting a paper with the desired qualities, specific visual effects can be achieved.

40. The translucency of a paper refers to the amount of light that can pass through it. The translucency of papers ranges from tracing vellums that are nearly transparent to bond papers that are nearly opaque. Pictured here are two popular marker papers lying over a line drawing. On the right is Canson Special Felt Marker paper that is clearly more opaque (or less translucent) than the Ad Art 307 paper on the left. Papers that are more translucent facilitate the use of underlay drawings as references for marker application, which results in a cleaner rendering surface and elimination of the time necessary to transfer a drawing to the paper. Translucent papers also permit the use of colored papers behind the illustration to alter the color and/or value of all or parts of the rendering.

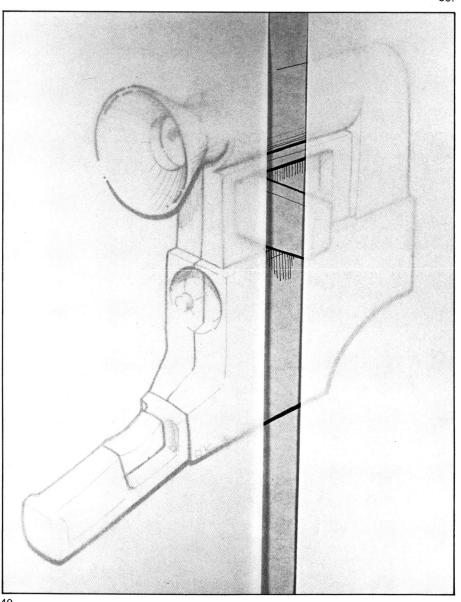

40.

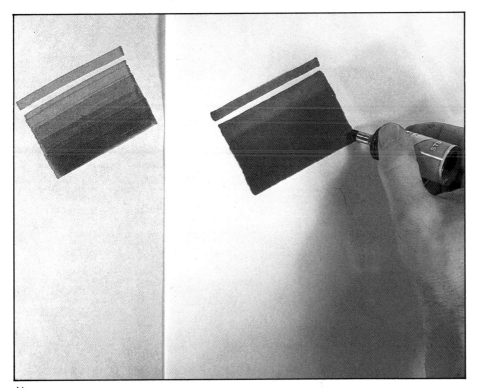

41.

41. The absorption rate and ink capacity of a paper refers to the speed at which the paper absorbs ink and the total amount of ink that the paper is capable of absorbing. Absorption rate/capacity ranges from very low in papers such as vellums that absorb very little ink, causing successive coats of color to "pool" on the surface of the paper, to high-rag content bonds that draw ink out of the marker at a high rate and produce a very saturated, intense color. To illustrate this quality, this illustration depicts a marker stroke above a field of color created with four successive coats of ink overlapping one another. The Canson Special Felt Marker paper on the right has a very high absorption rate/capacity. This is made evident by the fact that each marker stroke deposits more ink on the paper than does the Ad Art 307 paper on the left, which has a medium absorption rate/capacity. The difference in color is clearly evident in both the single stroke and the gradated field of color. While papers with a high-absorption rate/capacity produce more intense colors, they lack the breadth of value range that papers with a medium rate give. Papers with a high-absorption rate/capacity typically have a limited value distribution of marker color (usually on the dark side); this results in a soft overall appearance with blended edges between areas of color. Papers with a very low-absorption rate/capacity produce muted colors in a limited range of tonal values (usually on the light side); the result is a crisp overall appearance with clearly defined edges between areas of color.

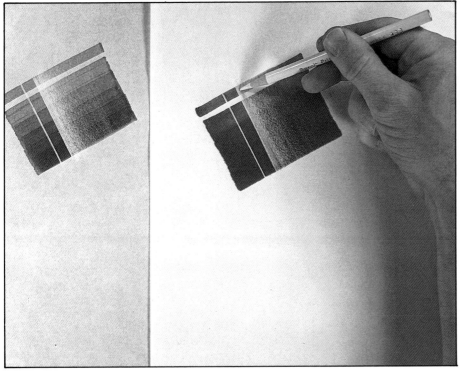

42.

42. Surface tooth refers to the roughness or graininess of a drawing paper. The degree of surface tooth ranges from papers such as vellum with a very low surface tooth, which causes pastels to appear transparent and pencil lines to be very weak, to bond papers with high surface tooth, which allows pastels to be opaque and pencil lines to be rich and distinct. To evaluate surface tooth, a white colored pencil line is drawn through the gradated field of color and a blended tonal range of pencil color is applied. As this illustration demonstrates, the surface tooth of both the Canson Special Felt Marker paper on the right and the Ad Art 307 paper on the left is very high. The pencil color is rich and distinct and easily built up from a very light tone to opaque.

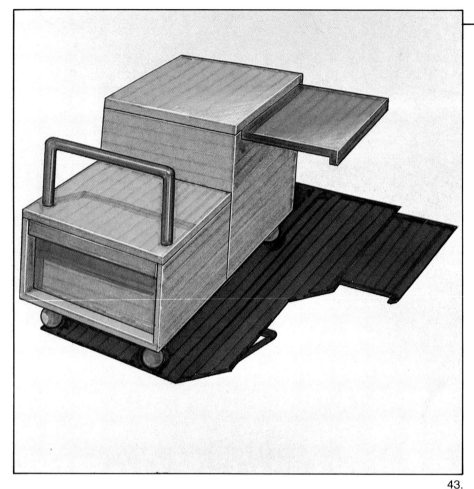

43.

Paper Comparisons

To demonstrate the stylistic options afforded by paper selection alone, these illustrations on the four most popular types of marker papers are identical in terms of markers used and application techniques. The differences in resulting visual effects are totally a result of the paper qualities.

43. This rendering was executed on *marker paper* with a medium degree of translucency, a medium-absorption rate/ capacity, and a medium-high degree of surface tooth. These paper qualities permit development of a complete range of tonal values and very well-defined colored pencil lines. The resulting "crispness" of line, edge, and color intensity is so popular with studio artists, product designers, and interior designers that it is the primary paper used for marker rendering.

44. This rendering on *blueprint paper* clearly illustrates the effectiveness of this material when markers are used in combination with colored pencils. Blueprint paper is used as a rendering surface primarily by architects but is also popular with product and interior designers. Because the material is opaque, it is not suitable for using line underlays as a reference for marker application; but those same underlays can often be used to make light-lined blueprints in multiple numbers by running them through a blueprint machine. It is for this reason that blueprints are useful when making several sketches of the same building, object, or environment, either illustrating color variations or minor design detail alternatives. The absorption rate/capacity of blueprint paper is rather high and because this results in very saturated colors, it prevents the renderer from developing a range of values within a color field by overlapping coats of marker color. In seeming compensation for this rendering limitation, blueprint paper has an excellent surface tooth that allows for brilliant coloration effects and shading with colored pencils and pastel.

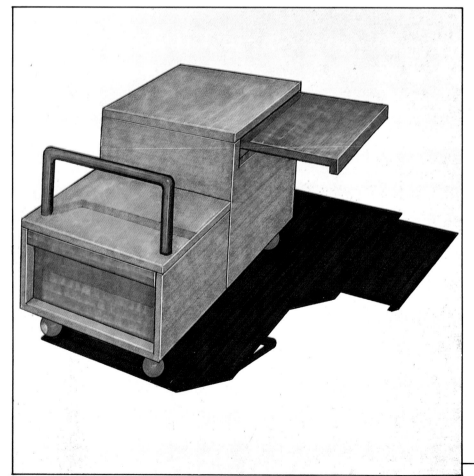

44.

45. This rendering was done on *tracing vellum*, which has a very high translucency. This translucency allows renderers to selectively alter the color tint and value of portions of the rendering by positioning colored papers behind the paper. Because tracing vellum has a very low absorption rate/capacity, the blending of values is rather abrupt and the intensity of colors is limited.

The surface tooth of this paper is moderately low, which results in rather subdued color pencil lines. Tracing vellum is popular because of the opportunities it provides to work on both sides of the paper surface to create various effects. The low-absorption rate/capacity also facilitates marker blending techniques. (See chapter 6.)

46. This rendering on *bond paper* illustrates the "soft" effect that this paper facilitates. Bond paper has a medium-high-absorption rate/capacity that results in very rich colors yet allows a moderate degree of value manipulation through overcoating. In addition, marker color "bleeds" on bond paper enough so that edges are softened, yet control of areas of color is maintained. Bond paper has a high degree of surface tooth, which allows for extensive shading and delineation with colored pencils. This paper is very popular with illustrators and interior designers seeking a softened, blended effect with strong coloration.

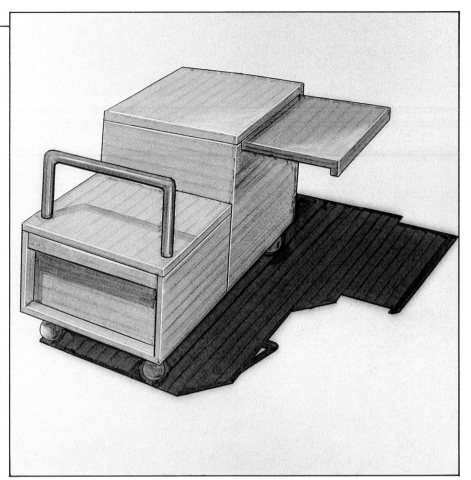

45.

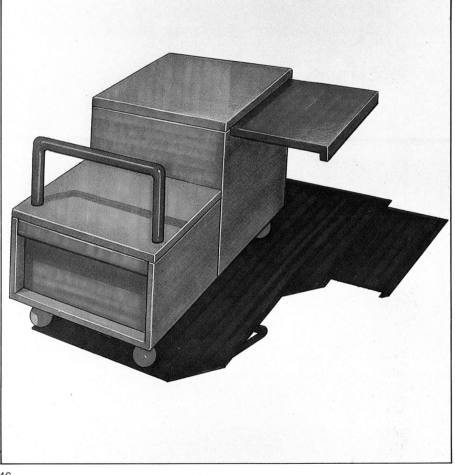

46.

47. This rendering uses a darker colored paper, which necessitates the use of more colored pencil for highlights than the previous example. Marker is used primarily to define shadow areas and the hair. This is a technique popular among illustrators who wish to achieve very dramatic illusions of lighting and material surfaces.

48.

Other Papers

48. The use of colored papers is popular among architects and product designers because the color of the paper can often be used to represent the color of the object being drawn. In this example, the gray of the paper serves as the middle-value color of the object. Darker values are achieved with gray marker application, and the highlights are created using colored pencils. The resulting visual effect of this technique is dramatic because of the intense lighting illusions that are developed.

49. This rendering on marker paper reflects the color of the matt board on which the rendering has been attached. Because of the sensitive and subtle use of the green reflections in the sprinkler, the rendering has a very dramatic illusion of light. It has what renderers refer to as "snap." As with the previous example, a gray shadow was applied directly to the green matt board to soften the visual transition between object and background.

50. Sometimes, the qualities of several different papers may be combined in a rendering. In this example, the shoe was rendered on marker paper and attached to a backgorund rendered on bond paper. The bond paper was first wadded up in a ball and soaked in water until limp. It was then flattened out and allowed to dry before blue pastel was applied to create the interesting texture. After attaching the shoe rendering, the shadow was applied directly on the bond paper. Papers can be a very effective part of your rendering technique. I urge you to experiment!

49.

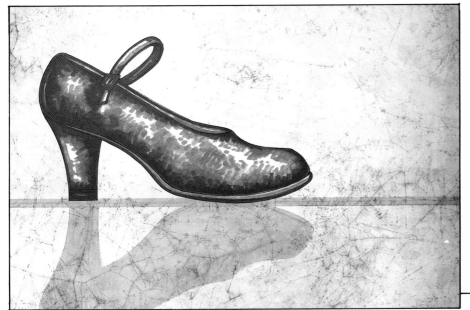

50.

CHAPTER 3

SELECTING VIEWS/ CREATING THE LINE DRAWING

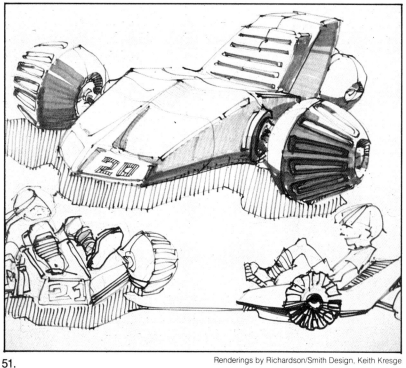

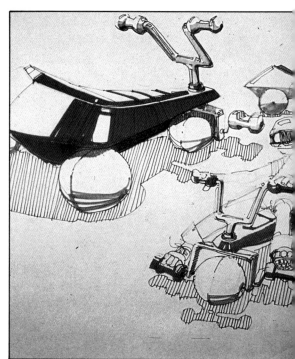

51.

Renderings by Richardson/Smith Design, Keith Kresge

52.

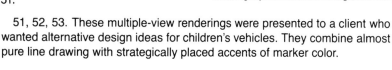

51, 52, 53. These multiple-view renderings were presented to a client who wanted alternative design ideas for children's vehicles. They combine almost pure line drawing with strategically placed accents of marker color.

Before any attention can be devoted to marker application technique, the renderer must have a line drawing from which to proceed. The production of an understandable and exciting marker rendering is dependent on first developing an accurate line drawing that delineates the appropriate amount of detail, presents the information from an appropriate visual viewpoint, and lends a sense of drama and excitement to the subject matter. If the renderer starts with an inaccurate, poorly orientated, or otherwise weak line drawing, no amount of flashy marker technique is going to salvage the rendering. As in cooking, the final product of a rendering is seldom better than the ingredients that go into it. This book does not pretend to be a text on how to draw accurate and effective perspective drawings. There are a number of excellent perspective drawing texts available, and if your skills are weak in that area, I strongly suggest that you devote some effort toward improving them. Your efforts will be rewarded with much more effective renderings and you will be able to work faster and with more confidence.

53.

In addition to drawing accuracy, the viewpoint of a rendering is critical to visual success. This viewpoint should be one that enables the viewer to see what the renderer wishes to emphasize. In many cases, a viewpoint that is familiar and recognizable to the viewer is most appropriate; however, an unusual or exaggerated view is sometimes necessary to evoke an emotional response to the rendering. Sometimes the viewpoint is manipulated to emphasize a particular detail or situation; other times, the viewpoint will be dictated by the purpose or end use of the drawing. Regardless of the view used, it should be selected by the renderer with sensitivity to the objective of the rendering. This chapter describes the types of views usually used in marker rendering and demonstrates how line drawings are used to guide marker application to the paper surface.

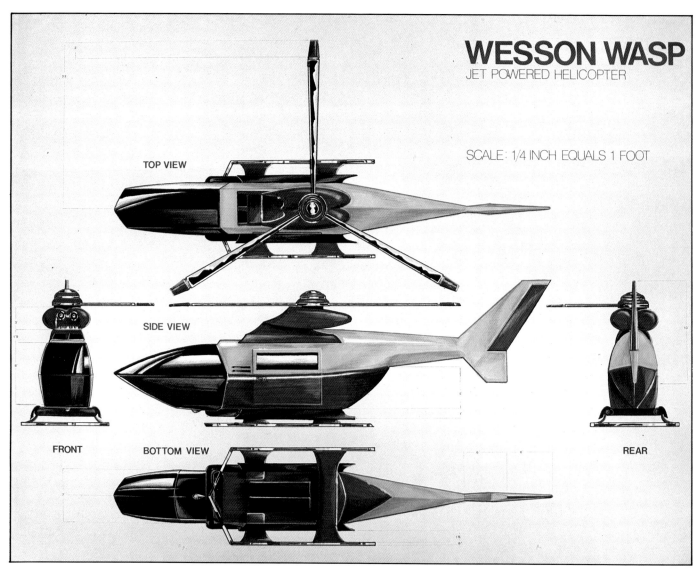

WESSON WASP
JET POWERED HELICOPTER

TOP VIEW

SCALE: 1/4 INCH EQUALS 1 FOOT

SIDE VIEW

FRONT BOTTOM VIEW REAR

Rendering by Jim Pester

Orthographic Views

54. Orthographic views are "straight-on" views of an object with no perspective indicated. They are usually drawn to an accurate scale and may consist of only one view or several, such as this rendering of a helicopter. These views are rich in information and when one view is referenced against another, a strong mental image of the three-dimensional form is created. This type of view is popular among architects and product designers and often with interior designers who render floor plans for client presentation. As in this example, orthographic views are most frequently rendered on blueprint paper because the line drawing originated as a pencil line drawing on tracing vellum.

56.

Rendering by Gil Born

The Three-Quarter View

55. The three-quarter view is the most frequently used of all graphic orientations of objects. Assuming the viewing of a cube, the three-quarter view allows the viewer to simultaneously see the top, the front, and one side of the cube—three of the four principal surfaces. This view is so popular because it provides the viewer with the maximum amount of visual information about an object within the context of a perspective drawing. The three-quarter view is especially popular with product designers, interior designers, and illustrators. This rendering of a chair demonstrates that a three-quarter view provides a tremendous amount of information about the object.

56. This rendering of an interior space simulates the view one would have when entering the room because the line drawing was constructed so that the horizon line is at the eye level of an adult person. Such a view is extremely useful for interior designers to allow a client to accurately visualize a proposed interior space.

55.

Rendering by Les Kerr

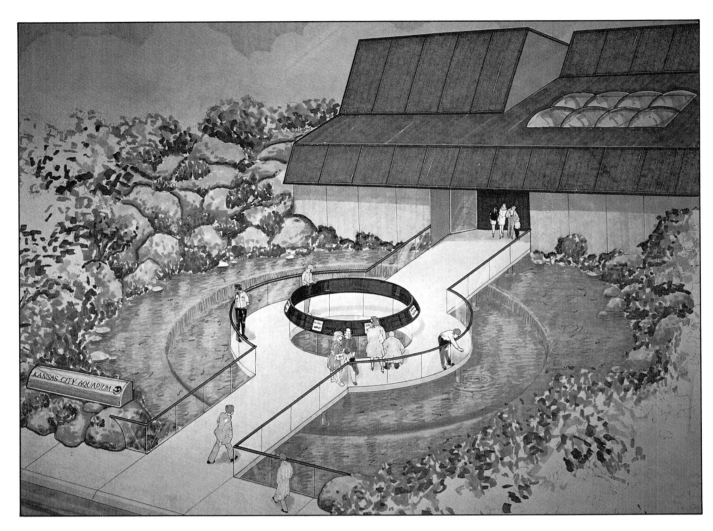

Bird's-Eye View

57. An elevated view is often required because of large amounts of visual material to be included or to give a more encompassing view of a large area. This rendering of an outdoor environment required the use of an aerial (bird's-eye) view in order to adequately describe the configuration of the pond and its relationship to the building and elevated approach. Because this design concept was based on a sequentially changing relationship with the space as one walks through it, it was impossible to illustrate the whole concept from a normal eye-level.

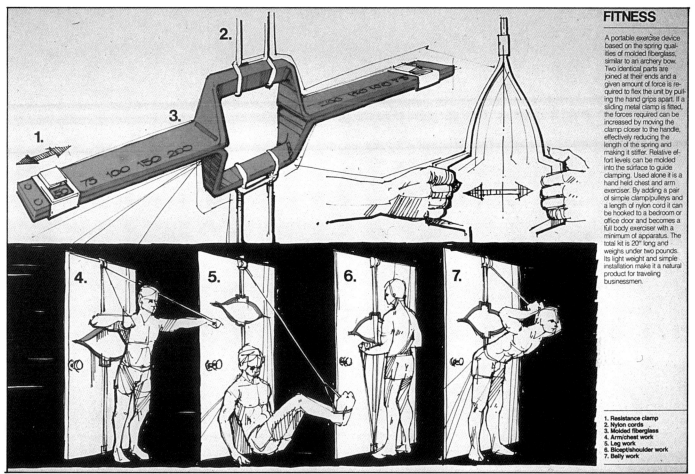

FITNESS

A portable exercise device based on the spring qualities of molded fiberglass, similar to an archery bow. Two identical parts are joined at their ends and a given amount of force is required to flex the unit by pulling the hand grips apart. If a sliding metal clamp is fitted, the forces required can be increased by moving the clamp closer to the handle, effectively reducing the length of the spring and making it stiffer. Relative effort levels can be molded into the surface to guide clamping. Used alone it is a hand held chest and arm exerciser. By adding a pair of simple clamp/pulleys and a length of nylon cord it can be hooked to a bedroom or office door and becomes a full body exerciser with a minimum of apparatus. The total kit is 20″ long and weighs under two pounds. Its light weight and simple installation make it a natural product for traveling businessmen.

1. Resistance clamp
2. Nylon cords
3. Molded fiberglass
4. Arm/chest work
5. Leg work
6. Bicept/shoulder work
7. Belly work

58.

Rendering by The Corporate Design Center, Inc., David Tompkins

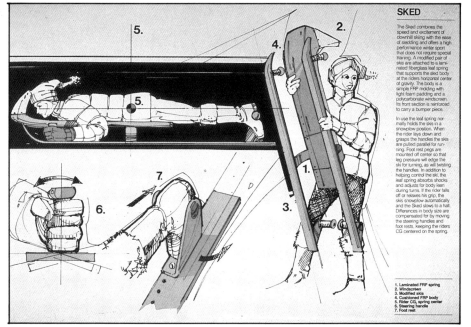

SKED

The Sked combines the speed and excitement of downhill skiing with the ease of sledding and offers a high performance winter sport that does not require special training. A modified pair of skis are attached to a laminated fiberglass leaf spring that supports the sled body at the riders horizontal center of gravity. The body is a simple FRP molding with light foam padding and a polycarbonate windscreen. Its front section is reinforced to carry a bumper piece.

In use the leaf spring normally holds the skis in a snowplow position. When the rider lays down and grasps the handles the skis are pulled parallel for running. Foot rest pegs are mounted off center so that leg pressure will edge the ski for turning, as will twisting the handles. In addition to helping control the ski, the leaf spring absorbs shocks and adjusts for body lean during turns. If the rider falls off or relaxes his grip, the skis snowplow automatically and the Sked slows to a halt. Differences in body size are compensated for by moving the steering handles and foot rests, keeping the riders CG centered on the spring.

1. Laminated FRP spring
2. Windscreen
3. Modified skis
4. Cushioned FRP body
5. Rider CG, spring center
6. Steering handle
7. Foot rest

59.

Rendering by The Corporate Design Center, Inc., David Tompkins

Multiple Views

58, 59. Designers sometimes use several views of the same object in one rendering. These renderings incorporate this practice in order to illustrate the product as well as its use. These renderings are a combination of marker line drawings with colored film overlays.

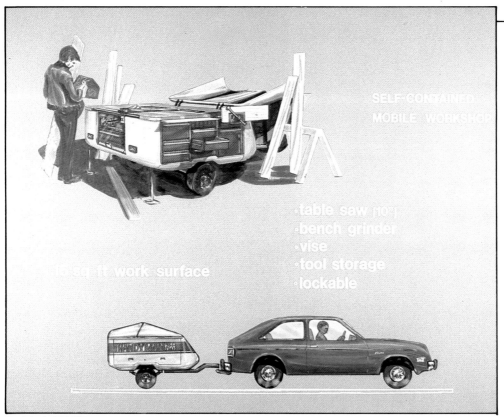

Rendering by T. E. Williamson

60.

60–63. This group of renderings of a professional work trailer concept incorporates a number of views of the product to maximize the amount of information conveyed. In addition to a three-quarter view (figure 60), this presentation includes a full set of orthographic views (figures 60, 61, 62) as well as an exploded view (figure 63), which illustrates the components of the design concept and how they relate to one another. This presentation is typical of the format used by product designers to visually communicate design concepts to clients. These renderings were executed on marker paper and then cut out and applied to illustration board.

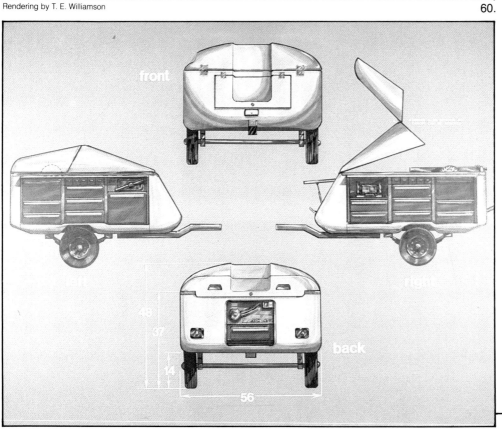

Rendering by T. E. Williamson

61.

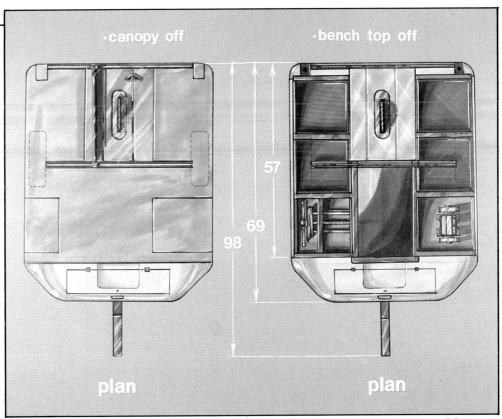

62.

Rendering by T. E. Williamson

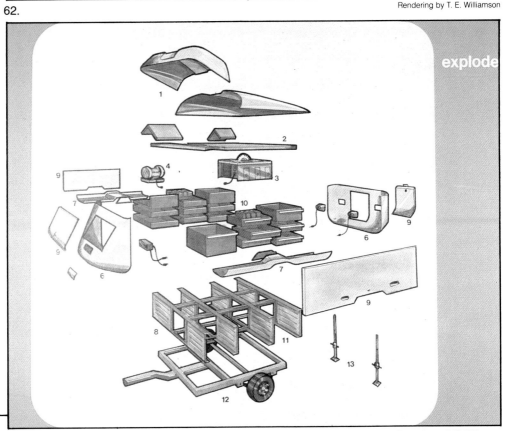

63.

Rendering by T. E. Williamson

Generating the Line Drawing for Marker Application

64. The line drawing for a rendering usually begins with quick "thumbnail" sketches that allow the renderer to consider view options and variations of design. The page of thumbnail sketches pictured is typical of how a product designer begins to examine design alternatives. After completion of a number of thumbnail sketches, a design (or designs) is selected for further development.

65. The selected thumbnail sketch is drawn in a scale suitable for the final rendering. I usually accomplish this step with a freehand drawing such as pictured here. As can be seen, I use many construction and reference lines to help make the proportions more accurate. These drawings sometimes get so busy with construction lines that I have to cover the drawing with another piece of paper and trace the lines that are correct. Many designers and illustrators use perspective grids for this stage of the drawing process.

64.

65.

66. When a suitable line drawing of the object is established, I construct the shadows, usually with a marker of contrasting color to avoid confusion later on. I usually manipulate the apparent light source so that the shadows enhance the surfaces of the form and "cradle" the object on the bottom and on one side. I feel this helps to give the object visual stability. It looks solid and as though it is resting securely on a hard surface.

67. When rendering on translucent paper, such as the marker paper pictured here, the line drawing can be positioned under the paper and used directly as a guide for marker application. I prefer this method because it saves time and allows me to apply the marker color to a perfectly clean piece of paper. Disadvantages of this technique are that the image is hard to see if the line drawing is light and the drawing can shift position during the course of marker application, resulting in a distorted image. To circumvent these problems, the line drawing can be transferred to the paper as is pictured here. I suggest using a fine-line ballpoint pen, preferably in a color matching or similar to the marker color that will be applied. I recommend ballpoint pens because the ink will not smear when marker is applied.

68. Using either the ballpoint pen line drawing or the image behind the translucent paper surface, proceed with the application of marker color.

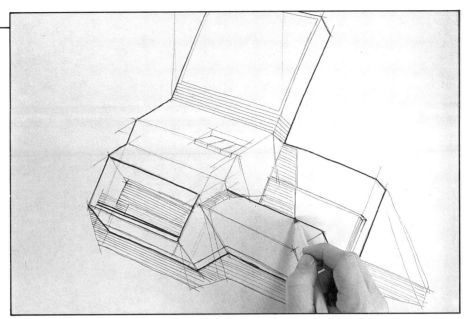

66.

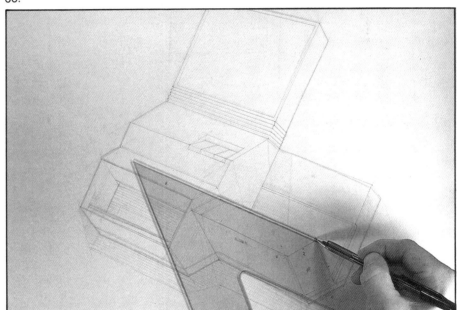

67.

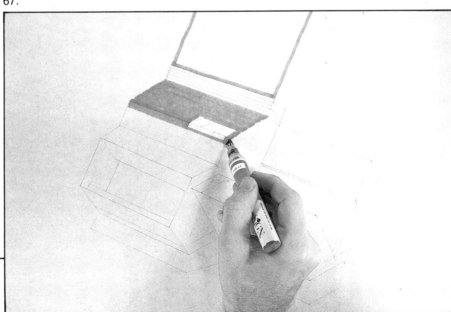

68.

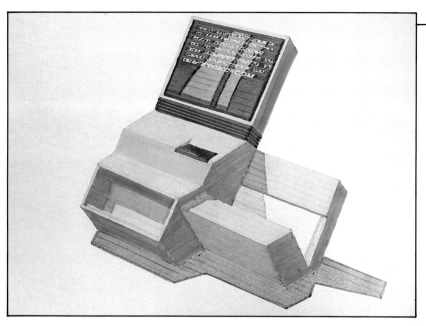

69, 70. The rendering with completed marker application in figure 69 is very effective for defining the form of the object, but lacks crispness of edge and strong highlights. This situation is remedied with the application of white (highlight) and black (shadow) lines to the rendering as illustrated in figure 70. Notice in figure 69 that all traces of the ballpoint pen lines have been concealed by the marker color.

71. The completed rendering has a full range of value distribution as well as lines that provide important visual clues as to the light source. The lines complement the marker color and give the rendering additional visual interest and strength.

70.

71.

Transferring Line Drawings to Opaque Paper

72, 73. Because of the opacity of some papers, the line drawing must be transferred to the paper surface. I use transfer tracing paper made to transfer sewing patterns to fabric. This material is readily available in sewing stores and is made in a variety of colors. It produces a weak, but usable image and does not smear when marker is applied. To transfer the line drawing, I secure the drawing to the rendering paper with tape and slip the transfer paper between the sheets with the colored side of the transfer paper touching the rendering paper as pictured here. In this case, I am using a gray Canson paper. I then draw over the lines with a ballpoint pen that transfers the image. If your drawing is complicated, you may want to cover the drawing with a sheet of tracing paper before you begin the transfer process so that you can keep track of the lines that have been scribed.

74. The rendering with completed marker application shows no residual effects of the transferred line drawing. As in the case with the previous example, this rendering has been enhanced with highlight and shadow lines.

72.

73.

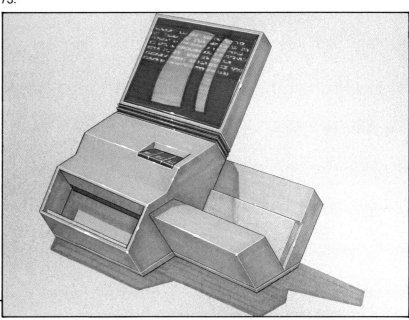

74.

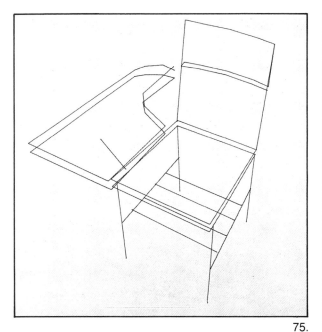

75.

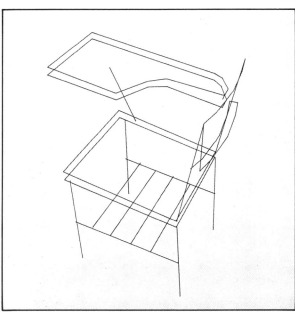

76.

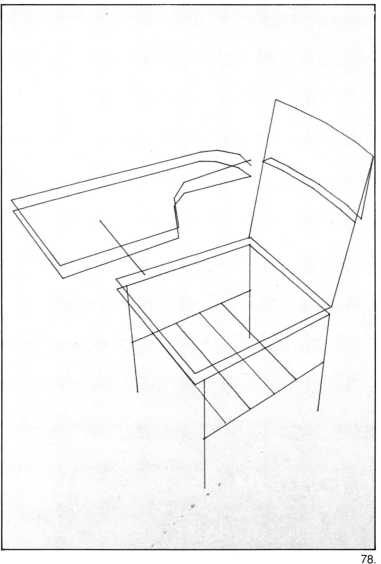

78.

Computer-Generated Line Drawings

75–78. The tedious process of constructing line drawings by hand may soon be relieved with computer-generated line drawings. The four views of a study chair pictured here are examples of this technology. In this particular example, the dimensions of the chair were fed into the computer in about fifteen minutes, using a graphics tablet. Once that process is accomplished, you can select any view of the object that you wish and quickly have a line drawing produced. This technology not only will save renderers time, but will allow them to view their subject matter from a greater number of angles than ever before. These four drawings took approximately six minutes to produce and most of that time involved attaching the paper to the plotter!

77.

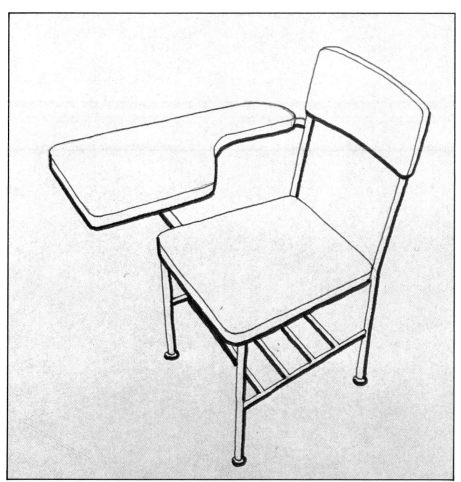

79.

79, 80. Although the line drawings produced by the computer are quite angular and show hidden lines, they are useful as underlays for refined hand-generated drawings, such as the one pictured here (figure 79), and, ultimately, the marker rendering (figure 80).

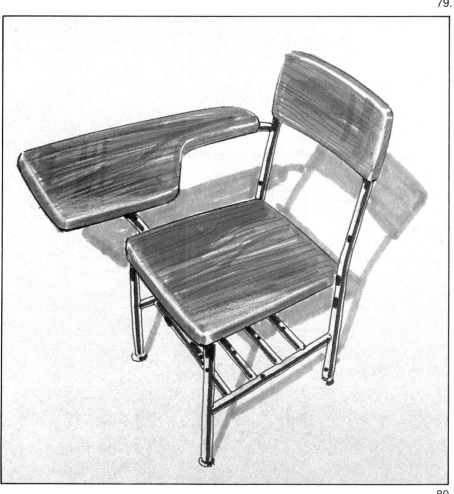

80.

CHAPTER 4
MARKER APPLICATION

81.

82.

Rendering by RCA Design Ce

81, 82, 83. All the renderings above employ conventional application techniques: figure 81 combines the blended parallel stroke technique with a spray marker background; figure 82 is an example of developing a subtle value range with the overcoating technique; figure 83 also uses the blended parallel stroke, but the value range was developed as a result of color selection rather than by overcoating.

T he tendency when first using a marker is to apply color to paper in much the same technique as one would use a crayon. The similarity in shape as well as the shared immediacy of the medium are probable reasons for this inclination. But whatever the reason, the result of one's first encounter with a marker is usually a visual mess that resembles my recollection of my first fingerpainting experience. Later, as some experience is gained, marker renderings begin to take on a more refined appearance, although they are still unmistakably crude. At this point, the drawings typically take on the visual texture of venetian blinds, a result of the overlapping of marker strokes and the uncontrolled bleeding effect of the inks. While novices might think this situation is permanent, I assure you that the potential for improvement is great. Markers can be controlled to a greater extent than you've ever imagined, and they are capable of creating blended fields of color that rival many other techniques for smoothness. The result depends on a variety of factors, including the type of papers used, the condition of the markers, the method of marker application, and secondary blending operations.

hard Bourgerie 83. Rendering by Ron Hayes

This chapter demonstrates the conventional methods of marker application and their use in various rendering applications. As your understanding of marker application techniques increases, you will be able to exert more control over the quality as well as the character of the blended marker strokes. As these skills and sensitivities develop, your stylistic options will increase and your renderings will become more individualized and expressive.

Using the Marker Tip

84. A key factor in maximizing the illustrative range of markers is the proper grasp of the marker body and appropriate application techniques. Although there are many body shapes and sizes of broad-tip markers, most are similar in their tip configuration. Most marker novices use the tip face for marking and bear down on the marker with so much force that the felt tip is crushed and deformed. Except for application techniques such as the scrub-coat stroke technique (described later in this chapter), only the working edges should be used. When a narrow stroke is desired, the tip edge can be used. By using the working edge of the tip, you will have maximum control of the colored mark in terms of directional control and consistency of color.

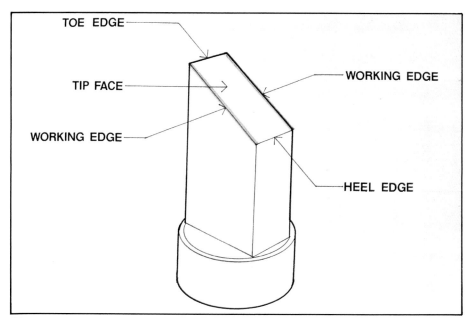

84.

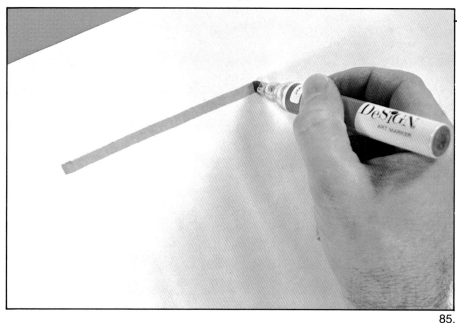

85.

Making a Mark

85. Hold the marker in your drawing hand so that you can see the point of contact between the working edge of the marker and the surface of the paper. With the working edge in contact with the paper, make a mark using a smooth, quick stroke in a direction away from your body. Don't allow the working edge to dwell on the paper at the beginning or end of the stroke as it will create "pools" of color. Maintain an even pressure on the marker and maintain a consistent speed of application in order to keep the flow rate of ink consistent, resulting in a smoother, more evenly colored field.

Blended Parallel Stroke Technique

86. The blended parallel stroke technique is used to create a smooth field of color. It involves laying down marker strokes parallel to and just barely touching each other but not overlapping. With some practice, you will learn to leave a very small gap between the strokes, which will "bleed" together forming a smooth field of color. Some renderers use a straight edge to assist in laying down straight strokes, which results in a very consistent but "hard" field of color. I personally dislike this method because it lacks the visual character that is obtained by laying down the marker strokes freehand.

86.

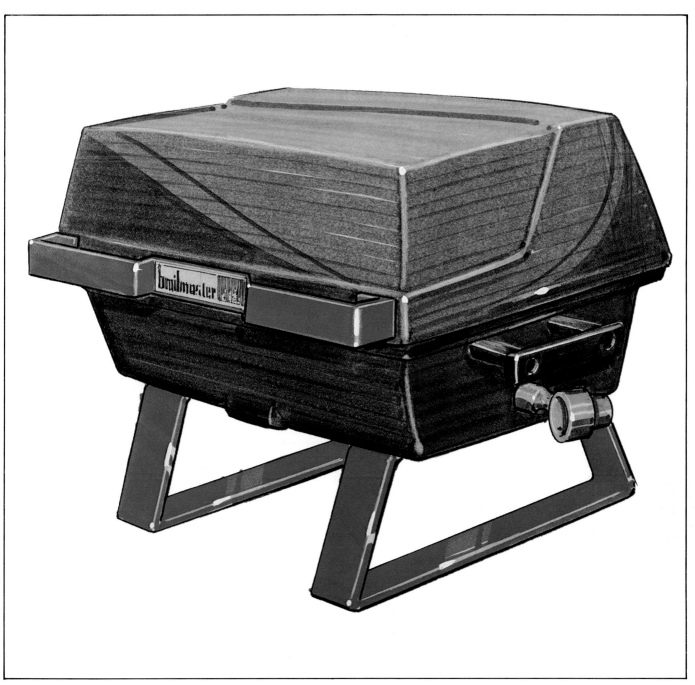

87.

Using Visible Marker Strokes to Your Advantage

87. Some overlapping or gaps between marker strokes is inevitable (especially when marking freehand) and results in what many refer to as "venetian blinds" or "zebra" strokes. Realizing that this is going to occur, try to control the direction of these strokes throughout the rendering so that these stripes help to accentuate the form.

Controlling Marker Stroke Width

88. When rendering with markers, it often seems that the final marker stroke necessary to complete a field of color must be wider at one end than the other. Such a mark can be made by rolling the marker between your fingers as the mark is executed until the width of the mark is sufficiently enlarged or reduced. This technique is also useful when applying color to extremely tapered areas such as the one pictured here. Using this technique, practice creating the tapered marks and work on blending parallel strokes of tapered marks into larger areas such as the one pictured here.

88.

Controlling the Angle of the Working Edge

89, 90. In a typical marker rendering, the beginning and end of each marker stroke is seldom perpendicular to the direction of the stroke. When creating irregularly shaped fields of color, the beginning of the stroke is often at an angle other than perpendicular to the stroke while the other end of the stroke is at yet another angle. To accommodate this situation, the marker tip must be properly oriented at the beginning of the stroke and rotated while making the stroke until it is in the proper orientation for the end of the mark. Practice this technique by making several straight marks beginning and ending at a variety of angles. When you get somewhat proficient at this, practice coloring irregularly shaped areas with color as smoothly and evenly as possible.

89.

90.

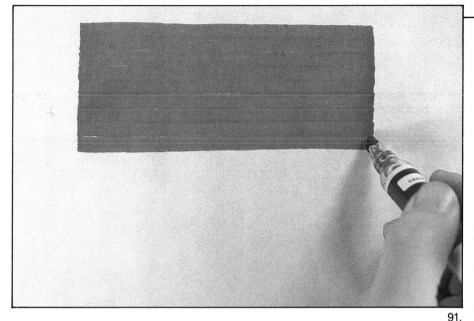

91.

Extending the Value Range of Colors by Overcoating

91, 92, 93. Once a smooth field of color has been established, the value range within the field can be extended toward the dark end of the scale by overcoating the field with a second, third, or more coats of color. When the first coat of color is dry, the next coat is added in areas of the field that are to be darkened or intensified. This overcoating must be done quickly and with light pressure on the marker so that the solvent-based ink will not dissolve the first coat of color and smear it. Marker inks are additive in nature. When overcoated, they maintain a consistent hue but darken in value. Some colors work better than others with this technique, depending on the brand of markers and the absorptive qualities of the paper used. When you buy markers with the intent of overcoating them to extend their value, it would be wise to test their effectiveness for this purpose before buying. The overcoating technique as described to this point is particularly effective on papers with a medium-absorption rate/capacity. Papers with a very high-absorption rate/capacity capture so much ink during the first coat that subsequent coats have little effect on the value of the original field of color. When applying this technique to a low-absorption paper such as a vellum, care must be taken to allow each coat to dry completely before adding successive coats of color. Once the paper has reached its saturation point and will absorb no more ink, it will "pool" on the surface and dry with a distractingly shiny surface. When this point has been reached, the addition of any more color on this surface will cause smearing. The shine, however, can be reduced or removed completely by carefully and lightly rubbing the area with a kneaded rubber eraser.

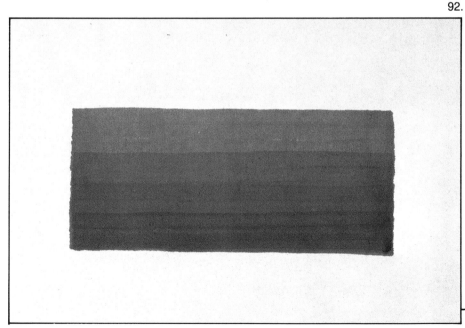

93.

Extending Values by Working the Back of the Paper

94, 95, 96. The value range of markers on translucent paper can be extended even beyond the marker absorption capacity of the side of the paper used for presentation by adding color to the back of the drawing. By defining the darkest areas of the illustration on the back of the paper using the same color marker as on the front, the values on the presentation side will appear darker because of the translucency of the paper. Using the same color marker for both sides of the paper results in a "purer" or unmixed shadow color, although with some colors, use of the same color will not result in the desired value change. In such cases, a similarly hued but darker value color, a gray, or even a black marker can be used on the back of the paper to create the desired value change. Be forewarned that using gray or black for such value extension often results in a muddy although darker color. Some papers, such as Art·tec No. 639, have a special coating on the back of the paper to prevent bleeding onto the paper surface beneath it. This coating prevents the successful use of this technique.

94.

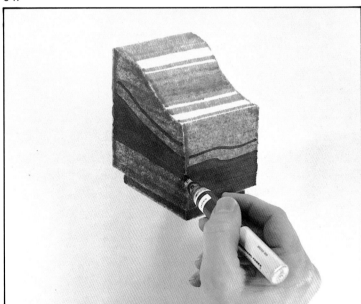

95.

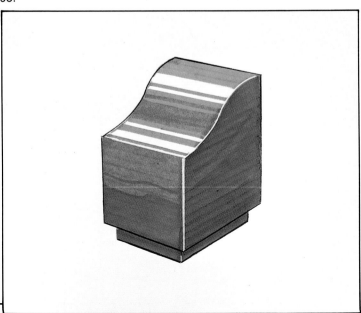

96.

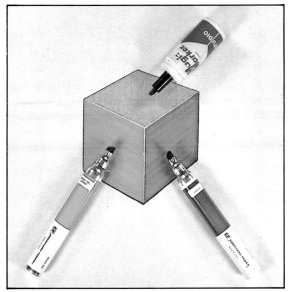

97.

Shading with Different Colors

97. Occasionally it is possible to match two or more marker colors of the same basic hue in a range of values. In this example, the three green markers are close enough in hue and different enough in value that they can be used to render a cube without overcoating. Matching up marker colors in this manner is a time-consuming proposition but the results can be very effective. The difficulty of finding colors that work well together is evidenced by the fact that two brands of markers were used for this example.

98, 99. Considering the time and effort required to match individual marker colors to create a value range, it is questionable whether it is worth the effort given the effectiveness of overcoating with one color. These renderings are offered to compare the techniques. Figure 98 represents an object rendered with the three green markers used for the example in figure 97. This rendering has no overcoating and all value differences are strictly the result of one coat each of the original marker colors. Figure 99 is a rendering made with the middle-value green marker used in figure 98. All value differences in the object are the result of overcoating. Three coats of marker color were used to define the shadow of the steps on the ladder sides. The principal difference between these two examples is that the shadows in figure 98 are slightly darker and more dramatic than in figure 99. Because of the overcoating technique used in figure 99, however, the green areas are much smoother because the overcoating has blended the marker strokes together.

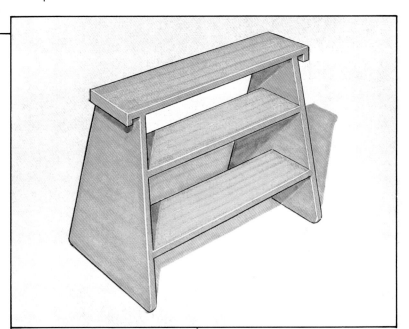

98.

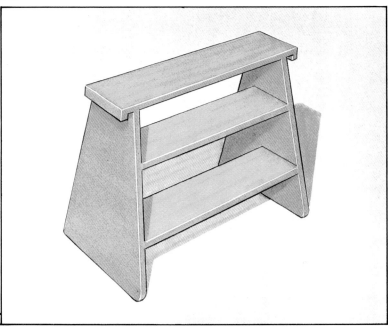

99.

Scrub-Coat Technique

100, 101. The blended parallel stroke technique is the technique most often used by renderers, but the other major marker application technique is the scrub coat. With the tip face of the marker in contact with the paper, lay down a coat of color using a rapid, randomly circular motion. As the tip face allows more ink to be absorbed by the paper, this technique must be applied quickly and with a soft touch to avoid getting the marker color too saturated and dark. By working quickly, the value of the field of color can be extended by overcoating selected areas of the field or on the back of the paper using the same application technique. The scrub-coat technique results in a very textural visual effect and is especially effective when depicting such materials as cloth, leather, vegetation, and other irregular surfaces.

100.

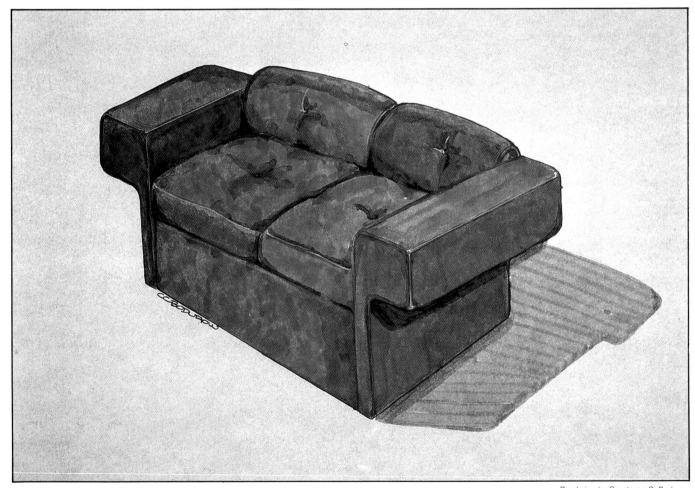

101.

Rendering by Constance C. Bodurow

Demonstration: Application Techniques

The following step-by-step documentation illustrates how the application techniques described in this chapter are used in the context of a marker rendering.

103.

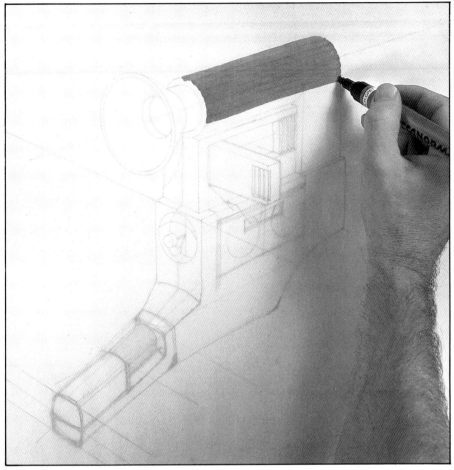

102.

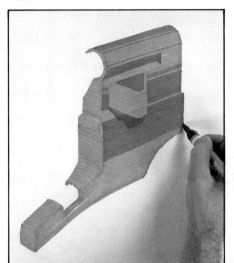

104.

102. The line drawing is positioned beneath a sheet of marker paper. Using the image seen through the paper as a guide, marker is applied using the blended parallel stroke technique. I am using a warm gray #5 marker for this demonstration.

103. Application of the first coat of color is continued. I often turn the paper so that the strokes I am applying are approximately parallel to my body and are made moving my hand from left to right. Here I orient the direction of the strokes toward the vanishing points so that they will accentuate the perspective.

104. By overcoating selected areas with the same warm gray marker, I begin to develop the value range of the object.

105. At this point I relieve the visual monotony of the large side panel of the object by overcoating the area in a flowing, diagonal pattern.

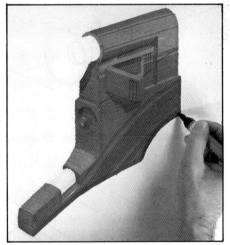

105.

106. Using a cool gray #9, I begin to define the lens hood and neck by indicating reflections. I use a #9 gray rather than black so that if I choose to overcoat it, I can create additional subtle value steps.

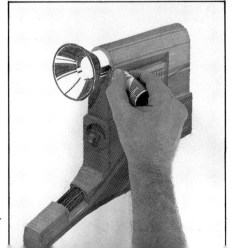

106.

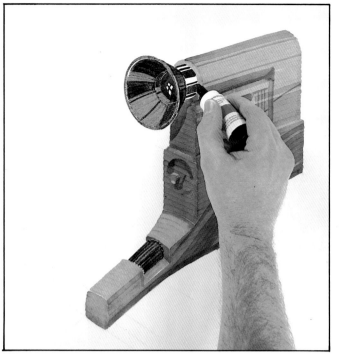

107.

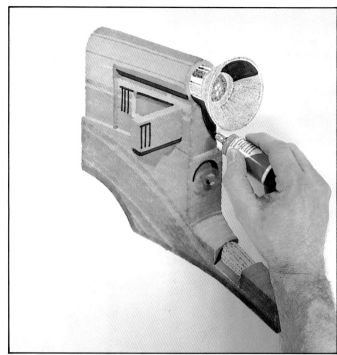

108.

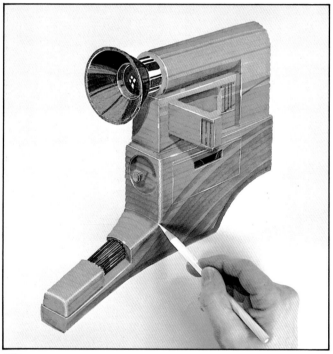

109.

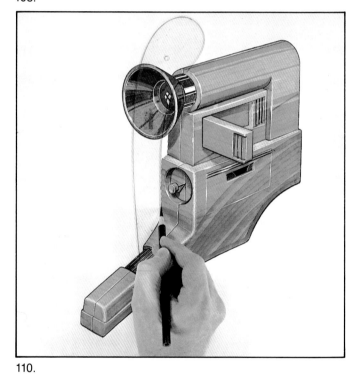

110.

107. Overcoating the lens hood with the same cool gray #9 subdues the reflection patterns and defines the overall colors of those components.

108. Shadows are accentuated by the application of cool gray #9 to appropriate areas on the back side of the paper. This application of color on the back of the paper has a substantial and positive effect on the value of the color on the front.

109. Highlights on the edges of the object are defined with a white colored pencil.

110. Outside edges of the object and shadow lines of the components are defined with a black colored pencil.

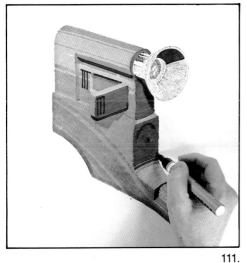

111.

111. Final value adjustments are made on the back of the paper. In this case, I determined that these surfaces needed additional contrast in order to give the rendering a bit more "snap."

112. I use colored pencil for final shading and blending of surfaces. As this completed rendering illustrates, it is possible to achieve a full range of values using only two marker colors and two pencil colors.

112.

CHAPTER 5
DEFINING FORM WITH MARKERS

113.

Rendering by Ron Hayes

114.

113, 114, 115. Although all of these objects employ the same basic principles of defining form, they were accomplished with different techniques. The cylindrical, three-dimensional forms in figure 113 were developed by a technique that is dependent on illusion, where the blending occurs in your eye but not on the paper. By contrast, in figure 115, subtle colored pencil shadings were used to define the compound curves of this flight simulator. The portable grill (figure 114) was developed by constructing a series of flat planes, with more emphasis given to defining its edges than to its surfaces.

The most effective method of defining a form with markers is to illustrate the reaction between light and form. When the highlights, reflections, and shadows of an object are defined, the form becomes apparent. The knowledge of how to depict light as it reacts with flat, rounded, spherical, compound-curved, and multiple-surface objects is essential in developing an expressive personal marker technique.

Although the depiction of form with markers is a relatively simple matter, it is a technique that is often misunderstood by marker novices. Beginners frequently overlook the sensitive manipulation of light and shadow that is required to define form. As a result, their renderings are often overworked, with every available space filled in. And without some white areas in a rendering, or some indication of reflected light, the delineation of form is extremely difficult to convey. Similarly, the shaded areas of a form are instrumental in visually defining that form. We interpret these kinds of visual clues regularly in our everyday lives; and without them, the world would become two-dimensional. Your understanding of the qualities that convey visual form is necessary for the realistic depiction of the world of objects.

This chapter explains how to define a number of forms using the principles of reflecting light and shadows. As you practice and refine your skills at incorporating these techniques into your renderings, you will become more effective in defining form as well as simulating the qualities of light and shadow.

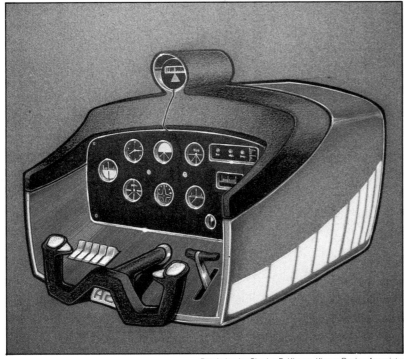

115.

Rendering by Charles P. Klasen, Klasen Design Associates

Flat Surfaces

116, 117. A flat surface that is in a horizontal position (such as the surface of a body of water) always has reflected highlights that are vertical to the viewer's eye. These reflections can be dramatically illustrated by leaving white spaces between areas colored with marker, using the blended parallel stroke technique. As a flat surface moves away from the horizontal position, the reflections become slanted to the viewer's eye. These types of reflections not only provide a visual clue as to the orientation of the surface, but they also provide some visual relief to what could become a rather monotonous surface visually.

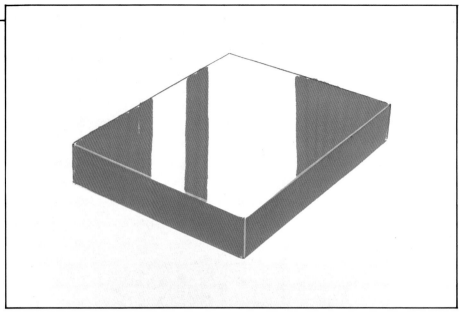

116.

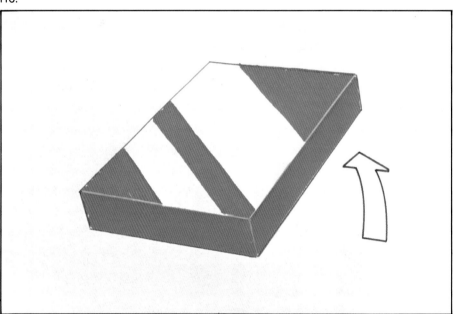

117.

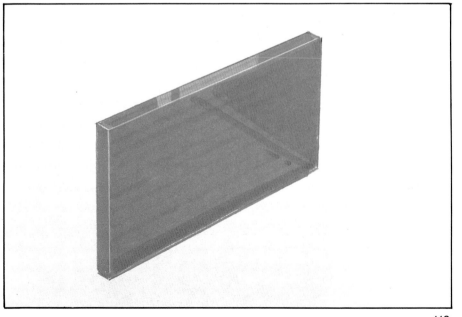

118. The reflections on the top surface of this object has been muted by overcoating the entire surface with a second coat of marker color. While subdued, these surface reflections still provide important visual clues and help to enrich the rendering. Objects with large, flat surfaces, such as the sides of these objects, often reflect their surroundings. This can be represented by laying down a complete field of color on the surface and then adding an abstracted simulation of reflections with either angular or fluid strokes. If these reflections are added to the surface in a very evenly toned and rhythmic manner, they will look quite natural and will enrich the rendering by giving it visual texture and the illusion of an active, exciting light condition.

118.

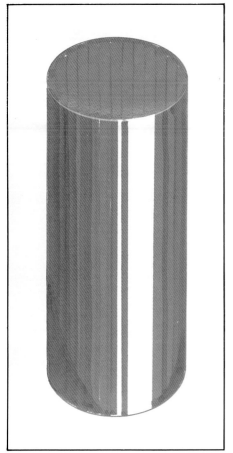

119.

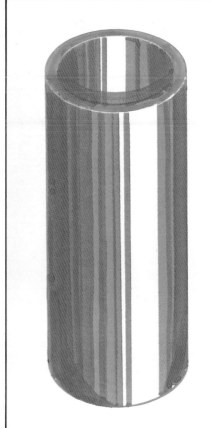

120.

Columns and Tubes

119. Round forms such as columns and tubes distort reflections and stretch them along the entire length of the form. These reflections are generally centered on the form near the point closest to the viewer. It is advisable to offset these reflections slightly to add a bit of asymmetry and visual interest. An effective means of illustrating reflections with markers is to lay in fields of color with the strokes of the marker parallel to the side of the column or tube and with several widths of white, clustered slightly off-center on the form.

120. Tubes are nothing more than hollow columns, so the outside surfaces are treated identically. The inside surface of a column also reflects the same technique as the outside. Reflections should be placed diagonally across the tube from those on the outside. The value of the inside surface is increased at the sides by overcoating.

121. The principles of illustrating reflected light on columns and tubes can be applied directly to more complex surfaces such as the form illustrated here. As with the reflections on columns, the highlights on a curved surface that is horizontal to the viewer's eye are clustered near the portion of the curve closest to the viewer's eye. Notice in this rendering how the direction of marker strokes was changed in order to delineate the reflections. When you encounter a situation like this, try not to overlap these strokes in different directions because unsightly blobs of color will result. I prefer to circumvent this situation by leaving a small gap at the point where the change in marker direction occurs.

121.

Compound Curves

122. Compound curves are those surfaces that curve in two or more directions simultaneously. Illustrating compound curves with markers demands sensitivity to the subtleties of light patterns and skill in blending and shading with markers. The strategic shape and placement of highlights as well as the direction of the marker strokes are critical in the definition of compound curves. The marker strokes should follow the contour lines of the form such as in this example. Because of the tapered form of this object, the marker had to be rotated during each stroke to vary its width. Notice that the highlights are also tapered so as to emphasize the form.

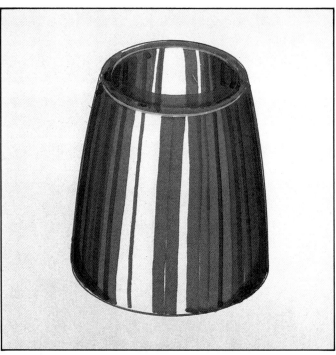

122.

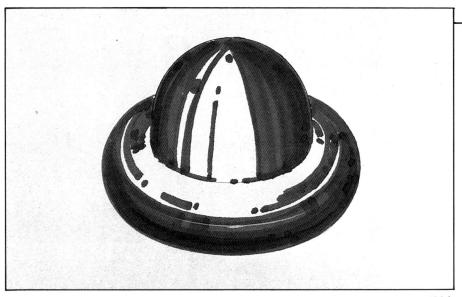

123A.

123A. When illustrating more complicated geometric shapes with compound curves such as the example here, it may be necessary to change direction of the marker strokes to define certain areas. In such a case, I try to situate a large highlight between the areas. In this particular example I have used a method I call the "Morse Code technique" to soften the transition from colored to highlight area. These dots and dashes of marker color must be applied in an asymmetrical and rhythmic pattern. Notice that this technique has also been employed in the shaded areas of the object.

123B. There are occasions when the character of the form being illustrated requires a "crosshatching" of marker strokes in order to achieve the desired visual definition of a compound curve. In such cases, all strokes should follow the contour of one of the curves. Crosshatching of marker strokes should be kept to the absolute minimum necessary to define the form. It can be effective when used with extreme moderation, but can quickly create a distracting checkerboard effect when overused.

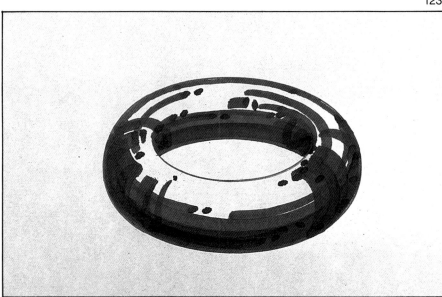

123B.

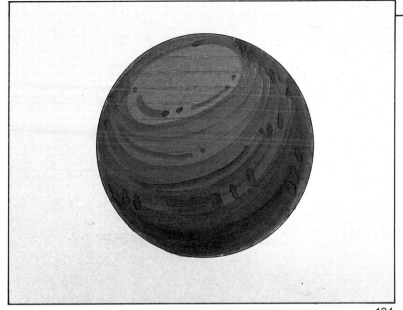

124.

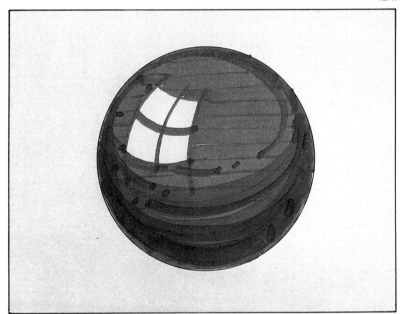

125.

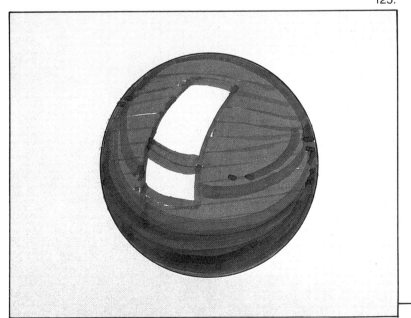

126.

Spheres

124, 125, 126. Spheres can be characterized by highlighting up to half the visible surface of the sphere. Reflections in a sphere are distorted by the surface of the form in such a way that the edges of the highlights conform to the contour lines of the form. Values of the sphere are built up by overcoating. The darkest areas of color should be at the bottom and toward one side of the sphere. The reflections can be delineated in a subtle fashion as in figure 124 or very boldly as in figures 125 and 126. The "window" reflection is one of the most popular and widely used visual cliches to describe a glossy surface. Although they can easily be overused, window reflections are especially useful in accentuating spherical forms because the "panes" of the window describe the contours of the sphere. The window mullions can be applied using a corner of the toe edge of a broad-tip marker or the pointed tip of a fine-line marker. The "exclamation point" reflection is simply a modification of the window reflection. It is successful because the edges of the shape define the contours of the sphere.

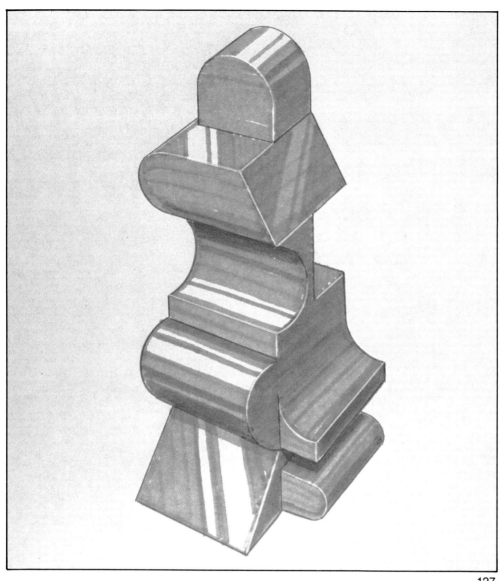

127.

Subduing Reflections

127, 128. Defining forms is often not as simple as merely depicting reflections in the proper locations. In complex structures such as the one pictured here, treating all surfaces as if they were independent of one another usually results in a visually "busy" and uncohesive whole. In a situation such as this, the visual congruity of the form can be enhanced by maintaining a consistency of position of highlighted surfaces and surfaces in shadow. By applying a coat of marker color over all the surfaces on the right side of the object (including the reflections), a visual order and cohesiveness of the overall form is established.

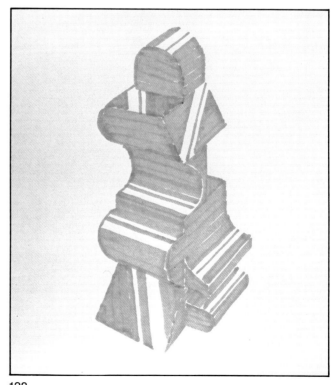

128.

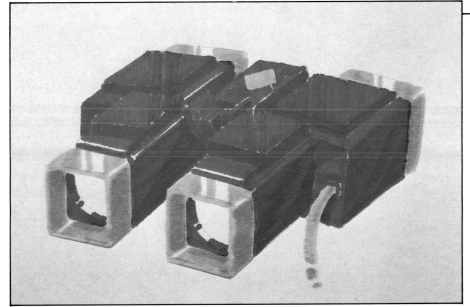

129.

Creating Soft Highlights and Shadows

129, 130, 131. The techniques illustrated thus far have treated highlights and shadows in a very bold and dramatic manner. There are occasions when a more subtle rendition of highlighted and shaded surfaces is required, particularly when the form is complex or has distinctive surface textural qualities. In these instances, highlights and shadows can be indicated by blending an appropriately colored pencil into the highlight or shadow area, using a very smooth technique of application. By creating a very gradual transition between the original marker color and the applied pencil, a very rich effect can be created. Note how some surfaces of these binoculars look glossy and other surfaces appear to have a soft texture.

130.

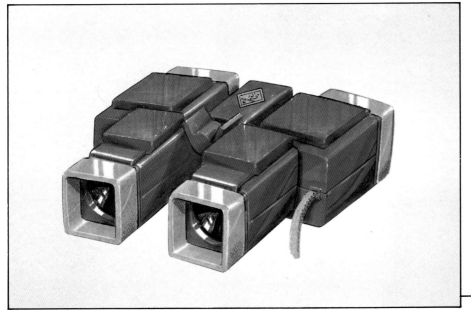

131.

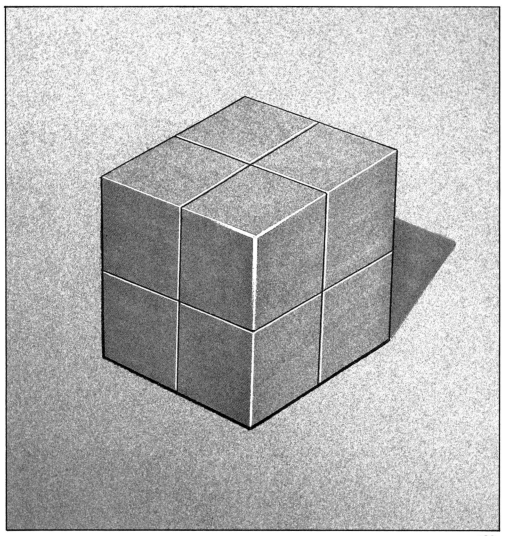

133. When more than one object is involved, most beginners get confused about the placement of highlight and shadow lines on a form. When eight cubes are stacked together as in this rendering, confusion abounds! Note that where one cube touches another, there is both a highlight and shadow line. Many people get confused as to which side the highlight and shadow lines should be. It is really quite simple when you realize that each cube is treated individually, just as it was in figure 132.

133.

Emphasizing Forms with Line Color

132. The form of an object and the reaction of light to it can be emphasized with the sensitive use of light and dark lines. Highlight lines are defined with light colored pencils, and shadow lines are defined with dark colored pencils. These colors can be matched to the areas of color to which they are being applied for a more subtle effect. I almost always use only black and white pencils regardless of the marker color because my personal technique calls for a crispness of line that these colors provide. Whenever I want a more subdued effect, I use pencils closer in color to the markers being used. This rendering demonstrates the arrangement of highlight and shadow lines on a very simple form. This arrangement assumes that the light source is behind and above one shoulder of the viewer. Note that the width of the line varies in order to enhance the qualities of light reacting with the cube. The highlight lines get wider (brighter) as they approach the corner closest to the viewer. The shadow lines are widest (darkest) on the bottom edge of the cube, which helps to give the illusion that the cube is resting on a surface and not floating in space.

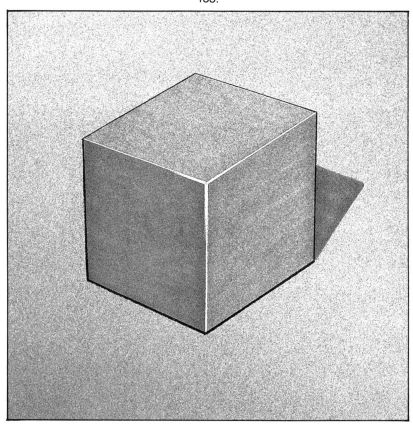

132.

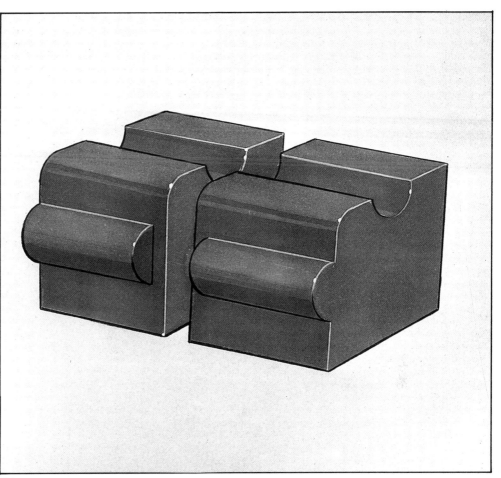

134.

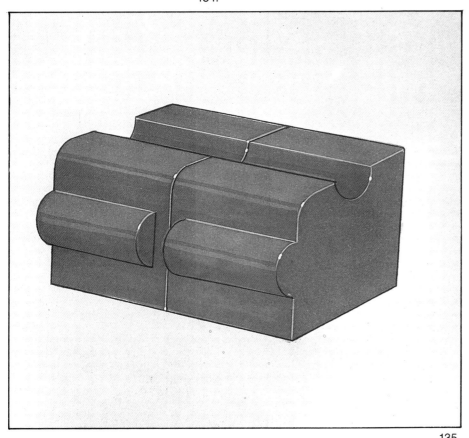

135.

134, 135. Another way to determine which side of a seam the shadow and highlight lines should be situated is to imagine the forms as individual entities with a space between them as in figure 134. Then, maintaining that arrangement of light and dark lines, push the two forms together, eliminating only those lines that are hidden by solid surfaces. Note how the edges of the round sections of these forms are treated. Each has a highlight line that gradually changes to a shadow line. This is easily accomplished with colored pencils by altering pressure on the pencil and gradually fading the line out. This ability to fade lines out, create a variety of widths of lines and vary a line from thick to thin and back to thick is why I generally prefer to use pencils for line work on marker renderings rather than fine-tipped markers.

136.

136, 137. In the rendering of the fishing reel with no pencil lines, the range of marker values adequately defines the form of the object, but the rendering lacks the crispness and sparkle that are so important in exciting marker renderings. By adding strong white lines on highlight edges, they appear to advance toward the viewer, thus helping to define the forms of the object. Dark pencil lines on all of the shadow-casting edges of the fishing reel cause those areas to recede, completing the illusion of three-dimensional volume as well as giving the rendering a visual richness and quality of light that it lacked before the addition of lines.

137.

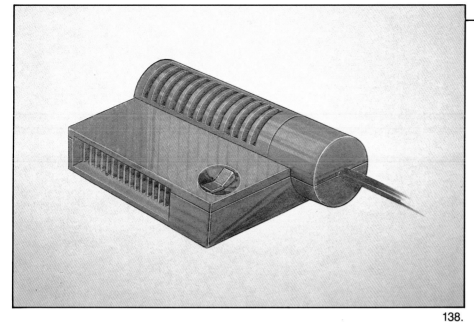

138.

Emphasizing Forms with Line Width

138, 139, 140. Variation of line width is essential in developing a strong illusion of three-dimensional objects. The lines of the hair dryer in figure 138 are all of equal width with no variation. While the lines are correctly situated in terms of light and dark lines, the illusion of depth is not exceptional. Perhaps more importantly, the rendering is visually dull. These lines were enhanced as shown in figure 139 by creating a range of line widths throughout the object. The lines fade from thick to thin with the thickest segments of the lines at the extreme shadow and highlight areas of the object. For example, the white edges of the round intake vents were increased in width at the point where a highlight is indicated by the marker color. The white edges of the dryer were visually rounded by softening the lines that define that portion of the object. The completed revision of the rendering has a much enhanced illusion of depth and has a great deal more visual character, entirely because of the change in line widths.

139.

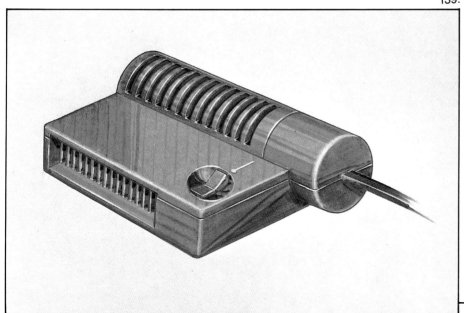

140.

Farkles

141, 142, 143. The intensely concentrated spots of reflected light that occur on forms in strong light are affectionately called "farkles" by many designers and illustrators. They are also referred to as hot spots, zits, and bullets. Whatever you prefer to call them, farkles are very effective in illustrating strong light conditions and/or highly reflective surfaces and edges. They are also very helpful in making edges and surfaces appear to advance toward the viewer, thus enhancing the dimensional illusion of the illustration. Best of all, farkles add life to the illustration. Farkles are applied after all marker and line applications are completed. Using a fine-pointed paint brush and white "Designers Color" (gouache), farkles are applied in shapes ranging from very small dots to long blended "farkle cigars." The dramatic visual effect is as if someone just turned on the lights! While farkles are very effective visually, they are so much fun to apply that it can become an addictive activity that can lead to an "overfarkled" rendering. Please, use restraint!

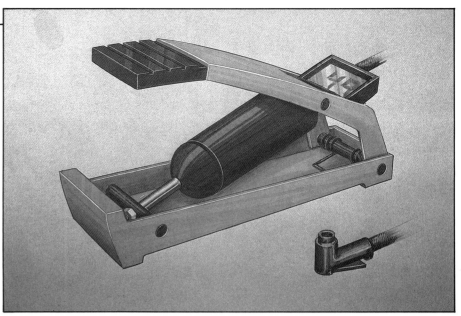

141.

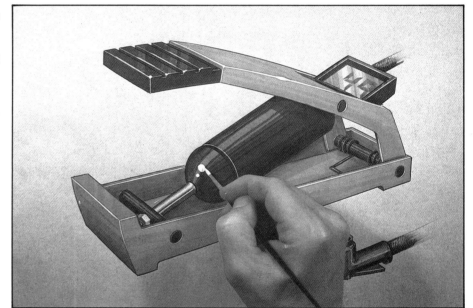

142.

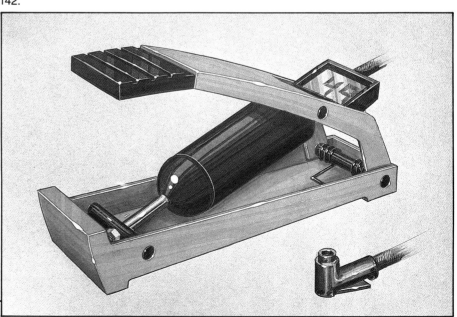

143.

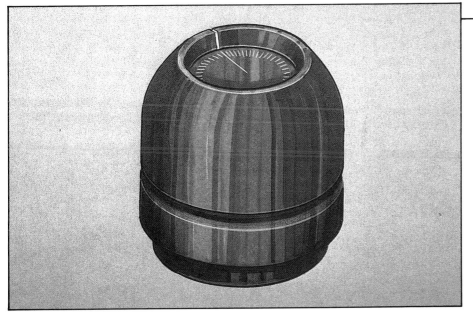

144.

144, 145, 146. Low gloss surfaces in very bright light can be effectively described using "soft farkles." Soft farkles are made with a white pencil instead of paint. The central position of the farkle is applied as heavily as possible with white pencil and then gradually blended into the marker color. The completed example pictured here has three soft farkles, which add visual interest to the rendering, define the surface quality of the product, and indicate a stronger, more realistic lighting condition.

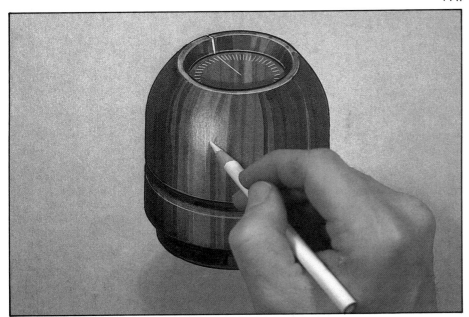

145.

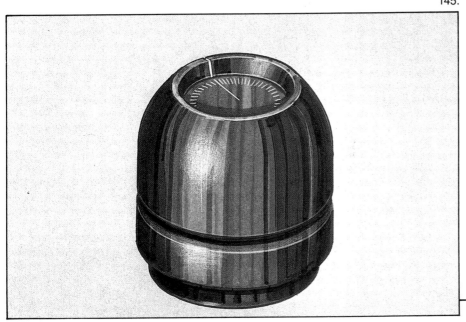

146.

Emphasizing Forms with Paper Underlays

147. Translucent papers such as tracing vellum result in such a limited range of marker values and background color that the definition of forms with reflections is limited. The value distribution can be greatly enhanced by cutting a sheet of white paper in the shape of the object and securing it to the back of the paper. The use of white paper as an underlay in this rendering of a complex medical work station accentuates the grays and intensifies the other colors. Perhaps most importantly, the paper imparts an overall color to the entire object. Other colored papers can be used for varying effects. I prefer to attach the paper to the rendering with spray cement, although some renderers prefer to use small pieces of double stick tape.

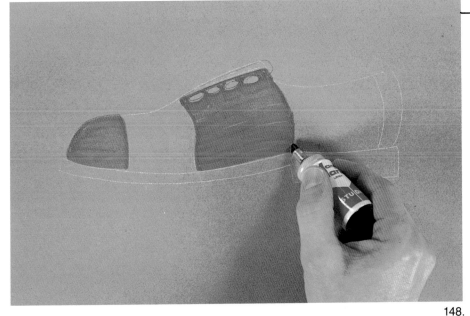

148.

Emphasizing Forms on Colored Backgrounds

The use of colored papers as a rendering surface is very popular because of the opportunity to use the paper color as an integral part of the rendering. Because of the marker color absorption qualities of this paper, conventional shading with overcoating techniques doesn't work well and must be compensated for with an increased use of colored pencil for highlights and shadows. Marker color has little effect on the definition of forms in this technique. This step-by-step example illustrates the sequence of rendering on colored paper.

148. Marker color is first applied to appropriate areas, which are always darker than the paper color.

149. Using a dark colored pencil, shadow areas of the object are added. Because of the excellent surface tooth of this paper, very rich, evenly blended shading is possible.

150. Highlights are then added using a white or appropriately colored pencil. Because of the brilliance of color intensity possible with pencils on this type of paper, this technique is very effective in creating dramatic illusions of highlight and shadow, which result in a very effective three-dimensional effect.

149.

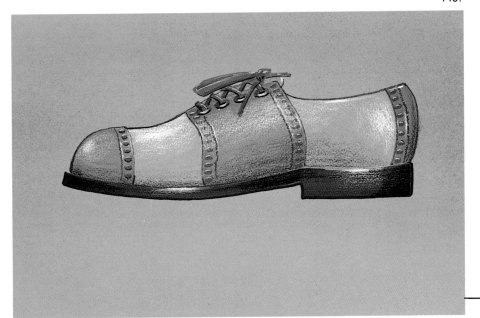

150.

CHAPTER 6

MASKING, BLENDING, AND EDITING

151.

152.

151, 152, 153. Frisket film (figures 151 and 152) and masking tape (figure 153) are both effective methods for sectioning off areas of precise marker color.

There are many occasions when the degree of marker control, delineation, and blending attainable with conventional application techniques is not adequate. Examples might include situations in which very small, or quite precise, areas of color must be delineated or when special blending techniques are required. Fortunately, when such situations arise, techniques can be employed that enable the renderer to exercise precise control over the medium.

In this chapter, several techniques are described and demonstrated that will increase the control over marker placement. Foremost among them is the technique of employing masks (either masking tape or frisket film) to prevent the marker ink from seeping past a defined area. This technique is one that I have modified from the use of masks with airbrushing.

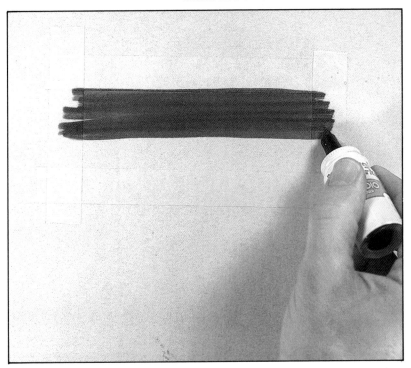

153.

Also demonstrated in this chapter is a solvent blending technique that makes it possible to duplicate some of the visual effects of airbrush shading. This ability to rework applied areas of color will give you an additional degree of control over marker shading as well as a much appreciated opportunity to modify marker color once it has been applied. This chapter also describes a technique that enables a renderer to cut and edit portions of renderings and combine several styles of marker application within the same rendering. This technique enables one to remove and replace sections of renderings in order to take advantage of the unique visual qualities of several types of paper within the same rendering. All of these techniques will help you to refine your marker application techniques and give you more precise control over the medium.

Masking Areas with Tape

154, 155, 156. Precisely defined fields of color can be created using masking techniques. In this demonstration, a geometrically shaped area is defined with masking tape and burnished down securely so that marker ink won't seep under the tape. Tape works best as a mask when the area to be colored has straight edges. If curves are required, they must be cut out of the tape. After the mask is applied, the marker color is applied. This is done quickly and with a light hand so that the ink is not forced under the tape. When the ink is dry, the tape can be removed. Avoid damaging the surface of the paper, especially if it falls within an area that will receive subsequent marker application.

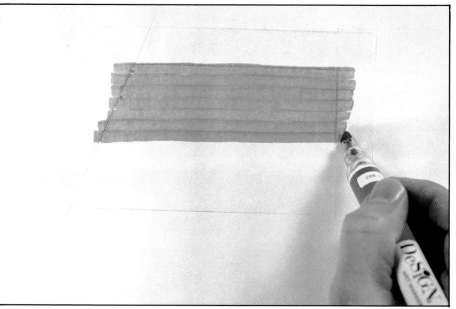

154.

155.

156.

157.

157, 158, 159. In this demonstration of masking on Canson colored paper, the mask is applied directly along all straight edges and cut with an X-Acto knife in the round area. Be very careful that you cut through the tape and not the paper. If you do cut too deeply into the paper surface, the cut will draw the ink into it by capillary action and cause an uncontrolled stain. The press-on lettering at the bottom of the page can also serve as a mask that will create reverse lettering. The marker color is shown being applied in figure 158. As you can see, the mask permits a very fluid, quick application technique because you don't have to concentrate on starting and stopping the mark at precise points. Figure 159 shows the press-on lettering mask being removed. After the ink has dried, a piece of masking tape is burnished over the press-on letters and then peeled off. The tape lifts off the letters revealing an unmarked area where they were. This is a very effective technique for applying interesting, colored graphics to a rendering.

158.

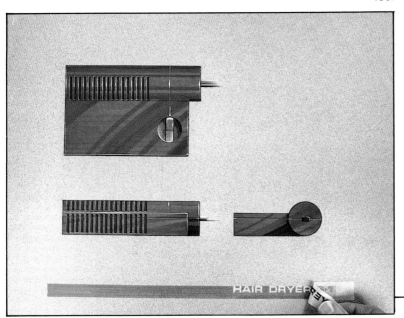

159.

Masking Areas with Frisket Film

160, 161, 162. Although tape is a very effective mask for simple shapes, the use of frisket film is much more satisfactory for very complex or small areas. Frisket film is a transparent acetate film with one side coated with adhesive. This adhesive backing is carefully peeled away as the film is lightly burnished onto the drawing. The film is then cut using a *very* sharp X-Acto knife and the film covering the areas to be colored is peeled away. Be very careful when cutting the film so that you don't cut through the paper. The best way to prevent this from happening is to keep that blade sharp and use very light pressure on the blade. After the film is securely burnished down (particularly along the cut edges) the marker color is applied with quick, light strokes so that the marker ink isn't forced under the film. After the ink is dry, the masking film can be carefully peeled away and discarded.

160.

161.

162.

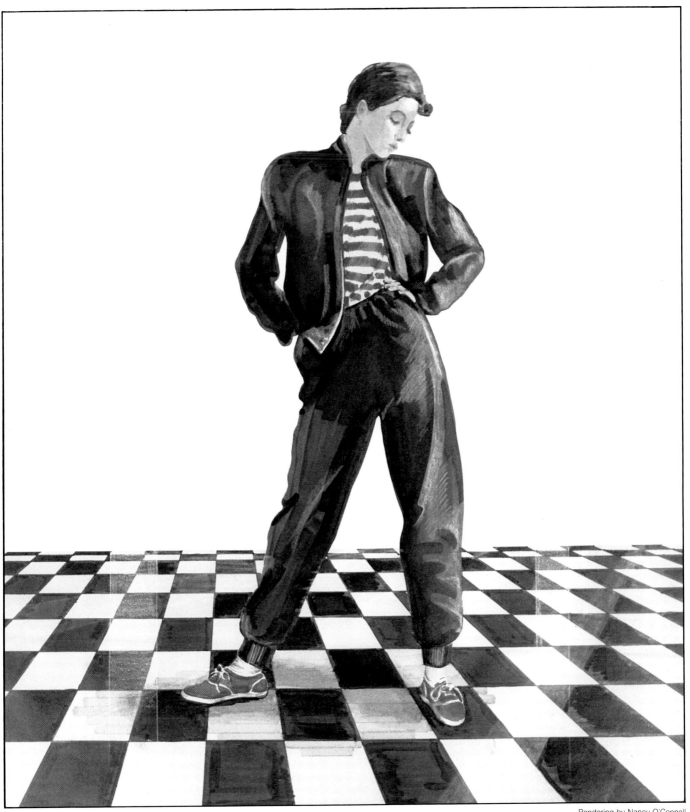

163. This rendering demonstrates the effectiveness of a frisket film mask. The black tiles are very crisply colored with precise edge alignment that could only be achieved by using a frisket film mask.

Wet-Coat Blending

164, 165. Papers with a low marker-absorption capacity allow a blending technique that creates extremely smooth fields of color. A high quality vellum such as was used for this demonstration is an extremely effective material for the wet-coat technique. All edges of the field to be colored must be masked with tape or frisket film before applying the marker color. When the ink is applied quickly and with uniform pressure, it will sit on the low-absorption paper for a short time before drying. It is during this period of time that the ink can be smoothly blended using a blending pad made from a clean white facial tissue, cotton ball, or litho pad. If the ink dries before the blending operation is completed, a few drops of lighter fluid on the blending pad will "wet" the surface sufficiently to complete the task. When the ink has dried completely, the mask can be carefully removed.

166. Subtle value gradations can be achieved with the wet-coat blending technique by gently lifting off some of the ink color from the appropriate areas with the blending pad. As in the case with the wet-coat blending technique, a few drops of lighter fluid on the blending pad will extend the amount of time available for completing this technique. When the ink is completely dry, the mask can be carefully removed.

164.

165.

166.

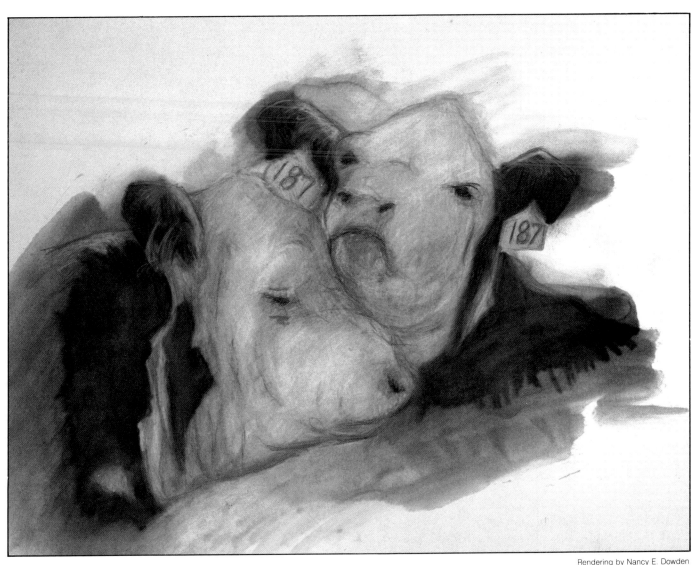

Rendering by Nancy E. Dowden

Blending Marker Color without Masking

167. Unmasked areas of marker color can be blended with cotton pads impregnated with lighter fluid. Depending on the size of the area to be blended and the paper being used, various degrees of control can be exercised. In this example, small areas of color were applied and then soaked with lighter fluid before being blended with a cotton pad. The resulting visual effect is quite distinctive and exciting. I encourage you to experiment with blending techniques and incorporate them into your personal rendering style.

Blending with Cotton Swabs

168, 169, 170. Another very effective technique for blending marker color is performed with cotton swabs. This technique is especially useful when masked areas are very small or when an area of dried marker is to be blended a section at a time. This demonstration shows how a rendering in which marker application is completed can be reworked with a cotton swab to blend out the stroke marks and create more consistent coloration. A drop or two of lighter fluid is added to the cotton swab and the tip is used to gradually wet and blend the color. This technique is conducive to working in very small areas, and it is possible to rework areas if they turn out unsatisfactory by going back into them with the wet swab tip. In this demonstration the stroke marks of the color field are blended so that they become very subdued and the color becomes much more even. This technique requires a very soft, patient touch to prevent the ink from becoming smeared or unevenly blended. Be careful not to exceed the boundaries of the color you are blending because the tip will carry ink color into those areas and stain them.

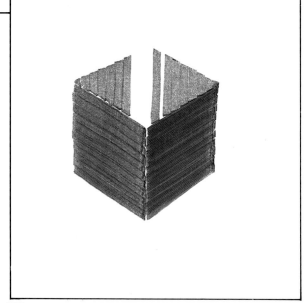

168.

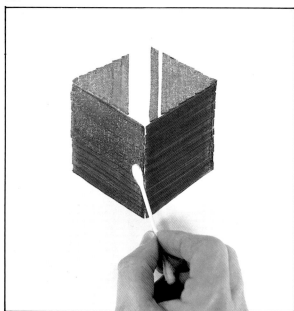

169.

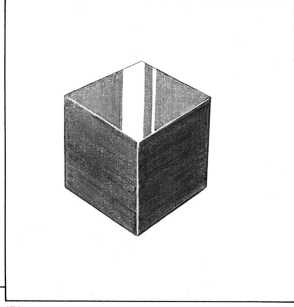

170.

171. The colors of the figures in this rendering were blended using cotton swabs. Highlight areas in the figures were created by lifting marker color with the swabs. The "ghost" figures that create the illusion of the band marching were made with the color-stained swabs used to blend the figures. The color created with color-stained swabs is very light and subtle—a very appropriate visual effect in this rendering situation.

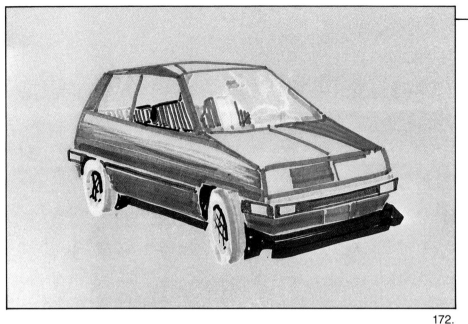

172.

Demonstration:
Masking Techniques

172. This step-by-step demonstration employs several of the masking techniques described in this chapter and illustrates how they can be used in the context of a rendering. Pictured here is a study sketch of the rendering that I used to evaluate light patterns and marker color combinations before I started the finished rendering. I find that these value studies save time in the long run by allowing you to concentrate on marker application technique rather than evaluating light patterns.

173. Regardless of the type of paper being used, I transfer a line drawing to the paper surface rather than using an underlay when I am using a frisket mask. This is done to increase accuracy. The protective backing of the frisket film is peeled away as the film is lightly burnished to the paper. It should be lightly burnished at this point to ease removal of those sections to be cut away.

174. Using a *very* sharp X-Acto knife, I cut through the film and remove the appropriate areas. Be careful that you cut through the film completely but not into the paper.

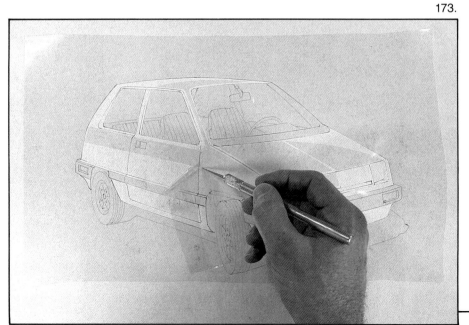

173.

174.

175. After the edges of the frisket film are burnished down very securely so that marker color won't seep underneath it, the marker color is applied.

176. Parts of the frisket mask are removed where additional blending operations will occur.

177. Using a cotton swab impregnated with lighter fluid, the marker color on the side of the car is blended smooth and lightly worked into the highlight area.

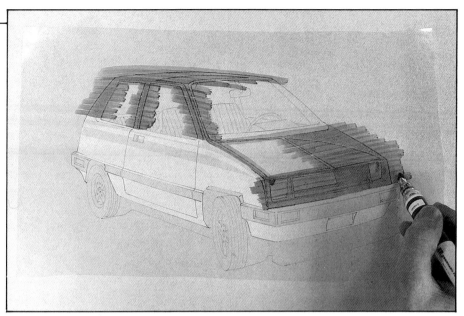

175.

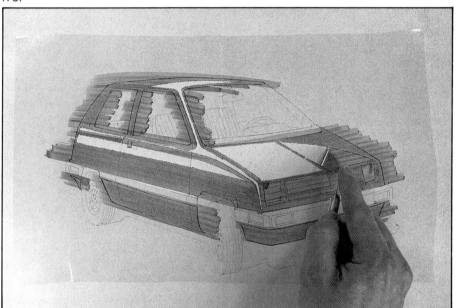

176.

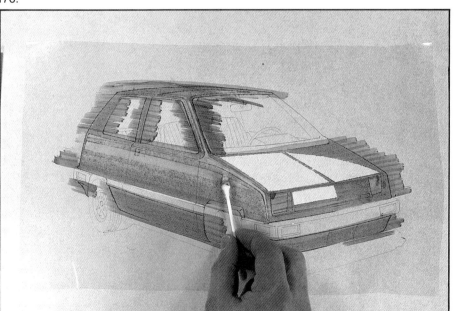

177.

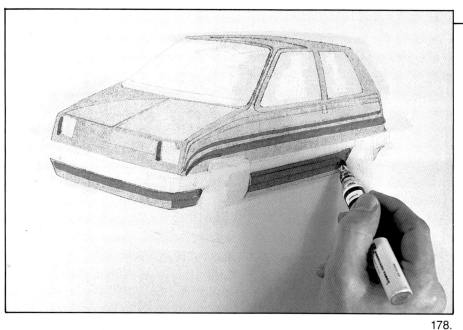

178. The same marker color as used on the front of the paper is applied to the back to emphasize shadow areas.

179. Returning to the front of the rendering, pastel is applied to highlight areas. I use pastel here because an appropriate color was available that could not be found among my markers. It was also used because of the subtle blending possibilities that pastel offers.

180. The pastel is blended into the rendering using another cotton swab impregnated with lighter fluid. Not only does the lighter fluid dissolve the pastel so that it can be blended, but it stabilizes it to the paper so that it doesn't have to be "fixed."

178.

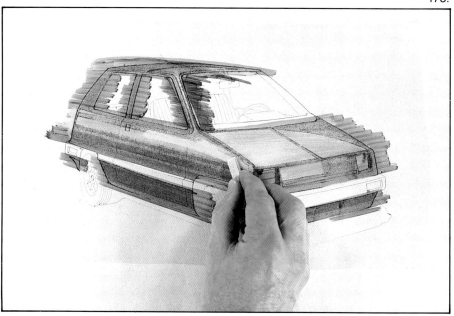

179.

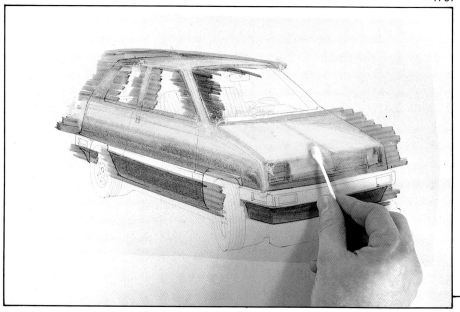

180.

181. The remaining frisket mask is removed and additional colors are added. The seats, windows, tires, trim, and shadow were created with a series of cool gray markers and black. Using a white colored pencil, highlights are blended into surfaces and edges are defined.

182. Outside edges of the automobile have been added to the rendering with a black colored pencil. Shadow lines and shaded surface areas are also defined at this time.

183. The final step in the rendering process is the application of farkles to spots of intense highlight reflections. The completed rendering represents the successful integration of a number of application, marking, and blending techniques.

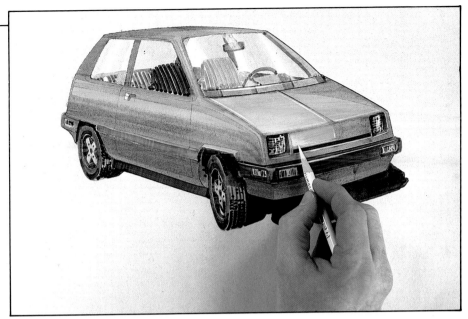

181.

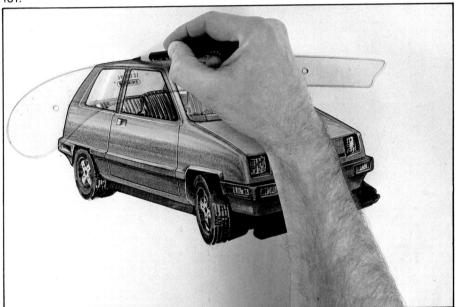

182.

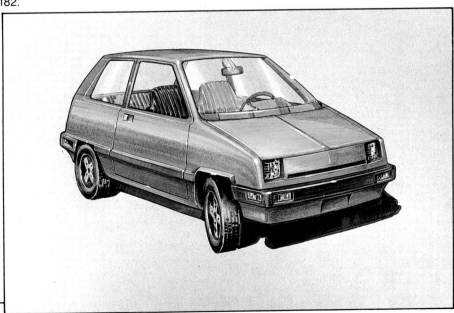

183.

Rendering by Gil Born

Image Editing

184. The bleeding of marker color that occurs on papers such as bond paper results in renderings with a "soft" look because of the fuzzy edges. There will be occasions when you might want to combine these qualities with other shapes, define sharp edges, or restore white space to the rendering. This rendering, which was done on bond paper, achieves this quality of sharp edge and crispness combined with softly blended areas through a technique called *inlaying*. This technique, which was developed by Gil Born, consists of cutting areas of the rendering out of the paper with a very sharp X-Acto knife and replacing that area with another piece of paper. In this particular example, the ceiling skylight and the window mullions in the foreground were inlayed after the rest of the rendering was completed. The sharp contrast of edge between these inlays works handsomely with the blended shadows in the background.

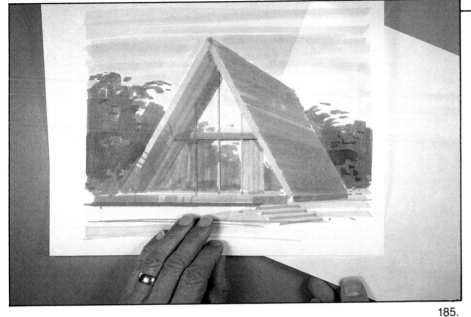

185.

Demonstration: Inlaying

185. The rendering is applied to the paper of your choice. In this case, bond paper is used, which results in colored areas that blend nicely into one another. This rendering is complete except for the images to be inlayed. Another sheet of the same paper is slid beneath the rendering and this "sandwich" is moved to a cutting surface.

186. Using a very sharp X-Acto knife, the image to be added is cut into the paper, cutting through both sheets. At this point the knife becomes a drawing tool, and the sharpness of edge and detail attainable is truly remarkable. Both pieces of paper are removed from the rendering, and the piece from the original rendering is discarded.

187. The piece of paper cut from the underlay sheet can either be colored at this point or inserted into the rendering. In this example, the handrail is colored to match the wood trim of the house before it is inserted into the rendering.

186.

187.

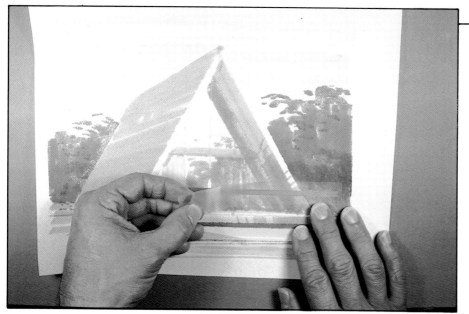

188.

188. The rendering is turned over and frosted transparent tape is applied to the paper. Frosted tape is recommended because it is almost invisible to the eye, and the adhesive has little, if any, reaction with the marker ink. It is also thin enough that it permits inlays to overlap without distorting the paper surface.

189. The rendering is then turned back over and the rendered railing is carefully inlayed into the appropriate area. If this shape was carefully cut out with a very sharp knife, it should fit exactly.

190. The rendering is turned over once again, and the tape is burnished securely against the inlay.

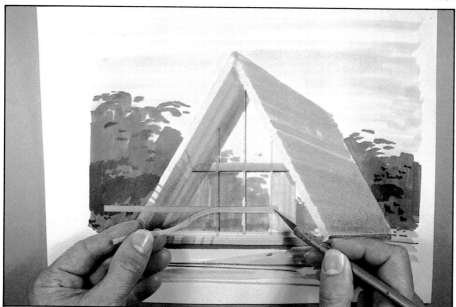

189.

190.

191. The rendering has been returned to its original position and the second sheet of paper slipped under the page; additional details have been cut into the surface. These inlayed tree trunks are now being colored with marker. Because the fibers of the inlayed pieces aren't connected to the original surface, the marker color does not bleed over the seam.

192. After areas are inlayed, additional marker color can be added to the general area, overlapping the inlay and the original surface.

193. It is possible to overlap inlayed areas. Note that the inlayed tree trunks overlap the porch railing. The completed rendering combines the desirable marker absorption qualities of bond paper and the crisp edges and details attainable by inlaying.

191.

192.

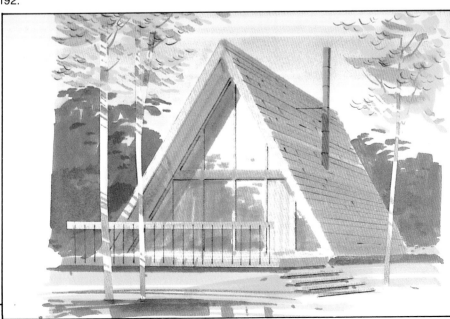

193.

Rendering by Gil Born

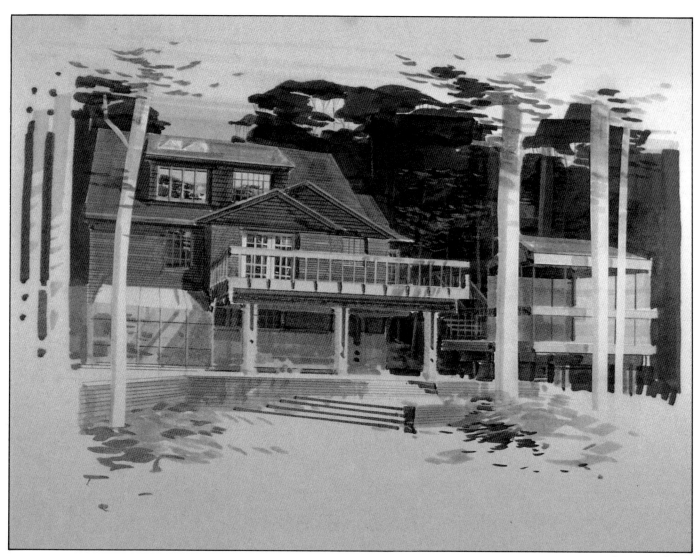

Rendering by Gil Born

194. Several areas of this rendering were inlayed including the tree trunks, the greenhouse, the porch railing, skylights, and parts of the screened porch.

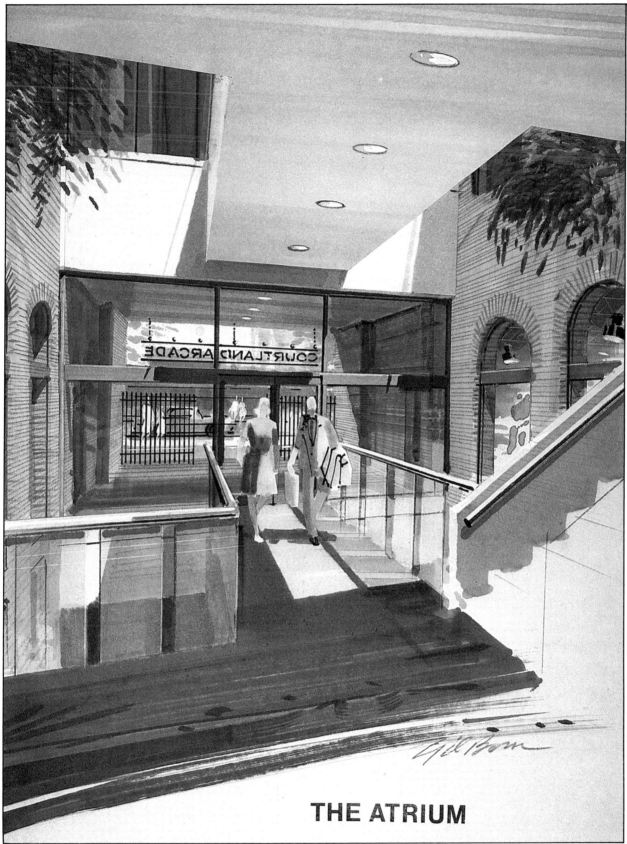

THE ATRIUM

195. In this interior rendering, the railings and skylights were inlayed. This is an example of restoring white space to a rendering that has been completely colored.

All of these examples illustrate the use of inlays of the same type paper. It is quite possible to inlay a mixture of papers for decorative effect or to take advantage of their unique physical properties. Experiment with this technique using a combination of paper types and colors. You may develop a technique that is exciting and unique.

CHAPTER 7
SIMULATING MATERIALS

196.

Rendering by Michael B. Staley

197.

196, 197, 198. The marker renderer should understand the particular visual features that characterize common, everyday materials, such as the chrome, leather, and vegetation pictured above.

The accurate representation of materials is a very important part of successful marker rendering. Materials must be so clearly represented that they are immediately recognizable. When marker renderings are used in a designer-client presentation, it is critical that there be no confusion as to what materials are being suggested. It would indeed be unfortunate if a designer were proposing a design of a glass object to a client who perceived the rendered material to be chrome. Such misinformation can be avoided by understanding the salient visual qualities of a material and then emphasizing those qualities in the rendering.

In addition to identifying the visual qualities of a particular material, the renderer must modify them so that they adequately define the form of the object as well as the material. This is often accomplished by the exaggeration of the material qualities of light reflection, surface color, and texture. Markers, by their distinct visual nature, are especially suitable to this type of exaggeration and work extremely well in depicting materials.

I have found through experience that the most difficult part of simulating materials is the identification and understanding of their principal visual qualities, such as the high reflectivity of plastic or the compression of values found on a chrome surface. This chapter describes those particular qualities found in a number of common materials—plastic, wood, chrome, brass, glass, leather, vegetation, and fabric—and demonstrates how to depict their qualities using rendering examples and step-by-step demonstrations.

198.

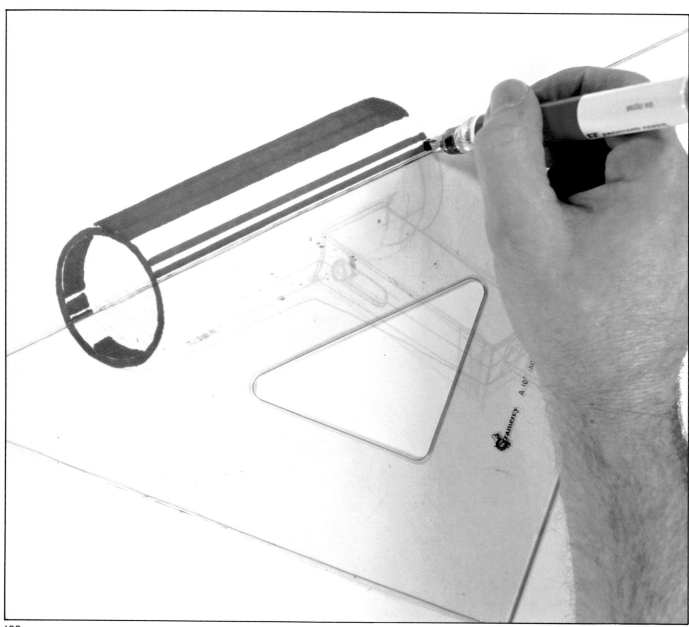

199.

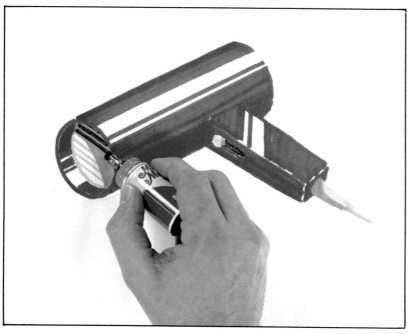

200.

Demonstration: Plastic

199. The principal visual quality of plastic is the reflectivity of the surface. Most plastic finishes are very glossy and display many reflections and highlights. These visual qualities are simulated in marker rendering by leaving generous amounts of white areas in the object. In this example, a wide highlight area is created on this hair dryer by leaving several bands of white. I use a drafting triangle as a guide for the marker in order to make the highlight edges as straight and crisp as possible.

200. The remainder of the marker color is added. Darker values are created by overcoating, which helps to define the form and also exaggerates the reflections. Notice that the reflection on the handle was created by changing the direction of the marker strokes from those used to define the long highlight on the body. Also notice that the remainder of the marker color is applied freehand, without the aid of the drafting triangle.

201.

201. Highlight edges are added using white colored pencil. Whenever possible, I use ellipse and circle guides to assure accuracy.

202. Outside edges and shadow lines are added with a black colored pencil. I prefer to use black instead of a color similar to the marker color because it produces a crisper visual effect that is appropriate for simulating plastic.

203. The completed rendering exhibits the very strong reflections that simulate plastic surfaces so well.

202.

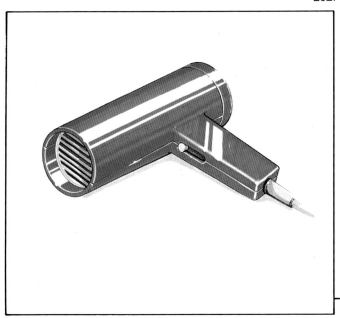

203.

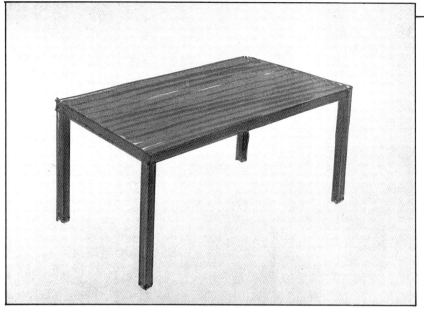

204.

Demonstration: Wood

The principal visual quality of wood is the modulation of color created by the grain. Many people try to simulate wood merely by applying grain lines. This usually results in a heavy-handed rendition in which the grain looks like applied graphics.

204. I begin defining a wood surface by applying a solid coat of color, usually medium brown. As illustrated here, I purposely overlap the marker strokes in a very carefree fashion, which results in an irregularly coated field of color.

205. I then apply a second coat of the same color in an even more irregular fashion. Using very light pressure on the marker (I barely let it touch the paper), I allow the marker to "skip" over the paper surface, creating an irregular pattern of blemishes. This develops the modulated field of color that is so important in depicting wood.

206. Wood grain lines are added using a corner of the marker tip or a fine-tipped marker point. Avoid the wood "knots" that so many novices feel compelled to draw. Instead, vary the line weight of the grain lines and develop a sense of rhythm with the spaces between them. The more variable these qualities are, the more natural the grain will appear. Try to depict the character of the grain of the wood you are illustrating. Oak, for instance, has a very wide variation in grain spacing while walnut has a tightly packed, straighter grain pattern.

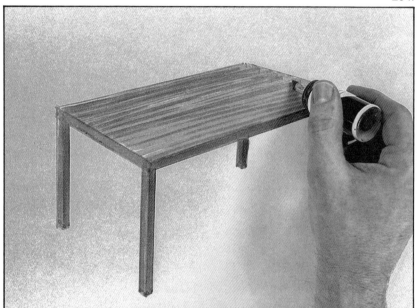

205.

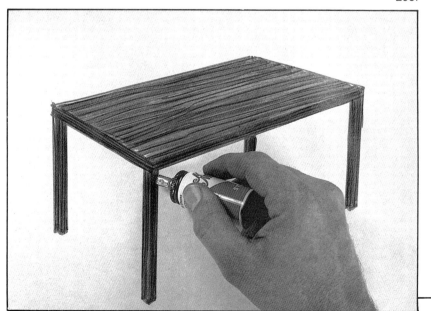

206.

207. The wood grain can be enhanced with colored pencil. This is a particularly effective method of creating highlight or shadow areas as well as introducing additional colors into the wood. This technique can be used to depict many wood types by substituting the appropriate marker and pencil colors and by adjusting the character of the grain lines.

208. After this highlighting is completed, outside edges, shadow lines, and some grain enrichment will be developed with a black colored pencil. The rendering could be considered final at this stage if the desired effect is wood with a matte finish or wood appearing in very low levels of light.

If a gloss is to be added to the table, it can be accomplished by adding marker color to the back of the completed rendering. Using vertical strokes, a pattern is created that indicates a highly reflective flat surface.

209. The marker pattern applied to the back has a dramatic effect on the front surface, making it appear to have a glossy, polished surface.

207.

208.

209.

210.

Demonstration: Chrome

The principal visual quality of chrome is the distortion of reflections and compression of values into hard-edged areas of black separated by highlight areas. The edges of chrome are typically a combination of highlights and reflections that are stretched along the edge as though they are fluid fields of color.

210. In this rendering of chrome-plated tubular initials, the first step is to apply black marker color to the shadow areas of the tubes. Because this particular rendering is so small, I use a "Sharpie" blunt-tipped marker to maintain maximum control of the lines.

211. Using a fine-tipped black marker, the smaller black reflections are added. Note how thin reflections transform into thick ones as the tube bends. The fine-tipped marker is also used at this stage to develop the outside edges of the tube, leaving a "ghost" highlight of white space between these edges and the reflections. This ghost highlight is critical in describing a chrome surface. The high contrast between the white and black areas is what creates the highly reflective appearance of chrome.

212. In order to visually enliven this particular object, small areas of black are added in an irregular but visually rhythmic pattern. This technique is also used to define shadow areas in situations where one tube overlaps another.

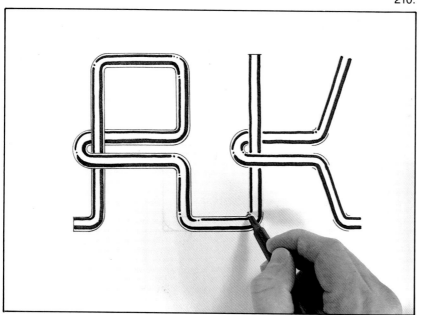

211.

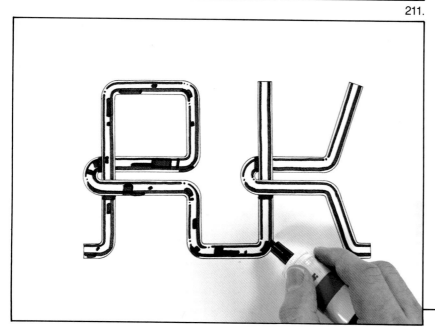

212.

213. In any chrome object, it is important to show the top of the object reflecting the sky and the bottom of the object reflecting the ground. This is done by adding a small amount of pale blue marker into a highlight area on top of the object. The ground reflection is suggested by adding a small amount of yellow ochre marker into the "ghost" highlight area at the bottom of the object. These reflections are so valuable in simulating chrome that I even use them in situations such as interior scenes where it would not be possible to reflect the sky and ground.

214. Farkles are added with white paint to enhance the reflectivity of the surface. When adding farkles to small objects such as this example, it is helpful to allow the farkle to overlap edges and reflections. This obliteration of edge enhances the illusion of surface reflectivity.

215. The completed rendering conveys the appearance of a busy reflective light pattern established by an intricate structure of chrome-plated tubing.

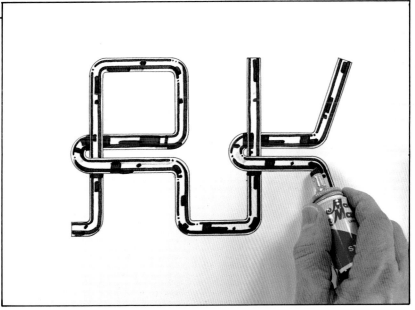

213.

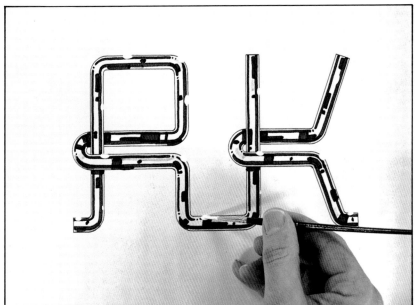

214.

215.

Chrome Tubes

216. Chrome tubes are defined by creating a variety of linear reflections along the length of the tube. The proportion of white to black is approximately half and half, with the white areas clustered in the highlight areas of the object. Sky and ground reflections are indicated by pale blue and yellow ochre markers.

Chrome Compound Curves

217. The flowing quality of the reflections in this shovel help to define the form as well as simulate the chrome-plated surface. When rendering chromed compound curves the ratio of black to white should remain at approximately half and half. The black areas should describe the contours of the object and should be as flowing and rhythmic in character as possible.

216.

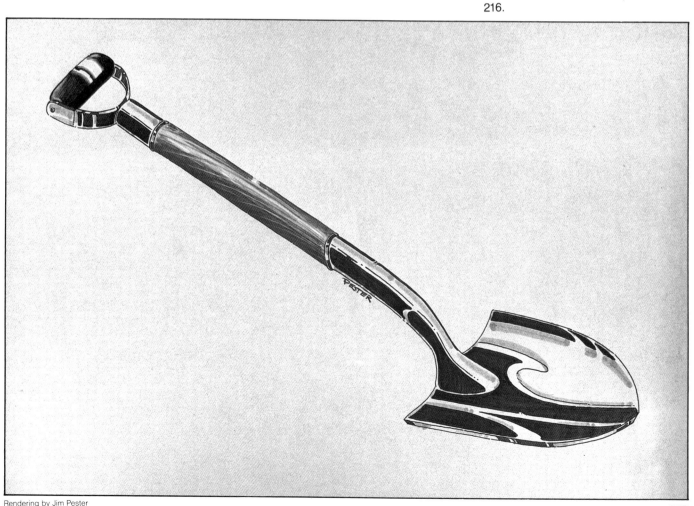

217.

Brass, Copper, and Other Metals

218. The reflective qualities of a material such as brass are so similar to chrome that I begin rendering such a surface just as I would if it were chrome. This example is identical to the first step of the process used to render figure 216. With the reflection patterns largely developed using black marker, I begin to add color appropriate to the specific metal I am rendering. In this example, I use a yellow ochre marker to simulate brass. Note that I preserve some white areas in the highlight zones in order to maintain the illusion of a highly polished surface.

219. This rendering of two brass candlesticks was first rendered as if they were chrome-plated by creating approximately equal areas of black and white. The addition of yellow ochre marker color to two-thirds of the white areas completes the illusion of highly polished brass.

218.

219.

Simulating Metal with Other Materials

Rendering by Sally A. Schulz

220. Chrome-plated and other metal surfaces can often be represented in renderings by actually applying small pieces of that material to the rendering surface. A variety of metallic tapes are available that are ideal for such an application. In this rendering, furnace duct tape was used to very effectively represent a metal surface with an embossed textural pattern. Experiment by using such materials in your renderings. You may develop a similar collage technique that is very effective.

221.

Practice Simulating Materials

221, 222, 223. Simulating various materials requires a sensitivity to the visual qualities of those materials. While this chapter describes how to achieve good results, the best way to develop your skills is to practice. Try an exercise such as the one represented by these renderings. Draw an object and then render that object in a variety of materials. Although a chair of this design would not necessarily be made of plastic, wood, or chrome-plated metal, the objective of such practice is to develop and refine your skills and techniques.

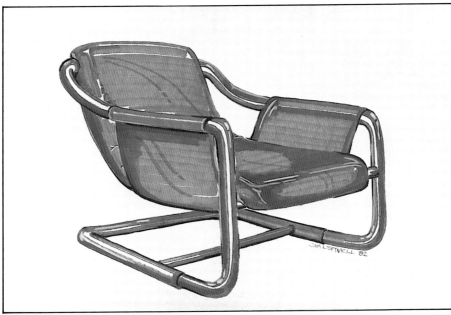

222.

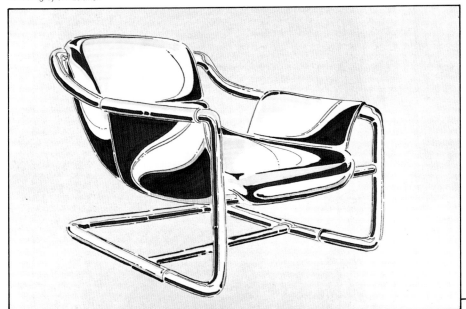

223.

Demonstration: Glass

224. The principal quality of glass is transparency. This transparency combined with the glossy surfaces of glass produce a very active surface of reflections, highlights, and distortions. To render glass, begin by outlining the object with a very light gray marker. Because of the transparency of glass, you should define all edges, even those that are behind another surface.

225. Using a very light gray marker, create a series of fields of value that simulate reflections on the various object surfaces. These reflections should be loosely defined and positioned in a manner that creates a consistent visual rhythm throughout the object. I use a very light marker at this stage in order to develop the pattern of light and reflection. The value range is developed later. Note how the top edge of the glass is defined by a white space.

At this point I have used the light gray marker to overcoat various areas of reflection in order to begin development of a value range. These darker values can be situated so as to help define the overall form of the object.

226. Next, using a darker gray marker, I fully develop the value range of the object, maintaining a liberal amount of reflection. The successful depiction of glass objects relies on a "busy" collection of reflections throughout the object. Note that corners of the object and areas where the glass wall is thicker are rendered darker than the areas of single glass thickness.

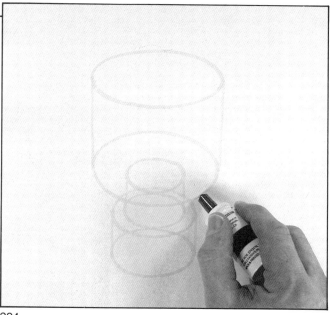

224.

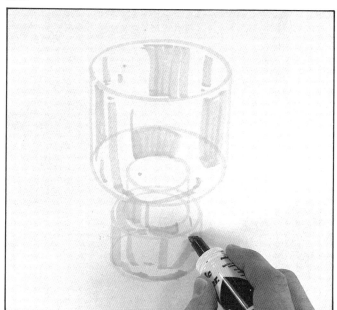

225.

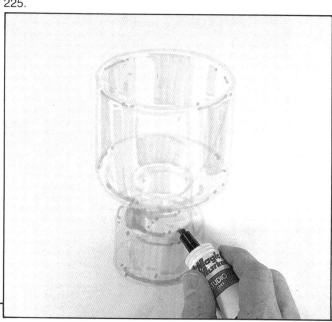

226.

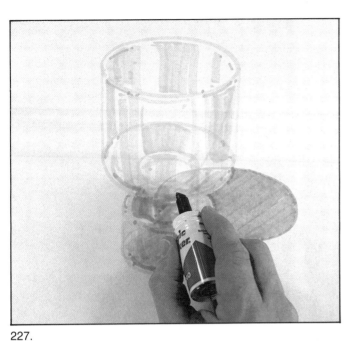

227. A key visual clue of a glass object is its shadow. Glass objects cast shadows that are light in value and somewhat irregular in consistency. When the shadow is viewed through the glass object, it becomes lighter in value than the shadow seen alone. In this example, a cool gray #3 marker was used for the shadow outside the glass object and a cool gray #1 was used to define the portion of the shadow seen through the object.

228. White and black colored pencils are used to define the edges of the object and minor reflections on the surfaces. They are used to delineate the thickness of the glass. The finished rendering illustrates a transparency of material as well as a highly active reflective surface. A cut-out piece of paper has been attached to the back of this rendering in order to brighten the appearance of the object. This lightening of value helps to increase the transparent quality of the glass.

227.

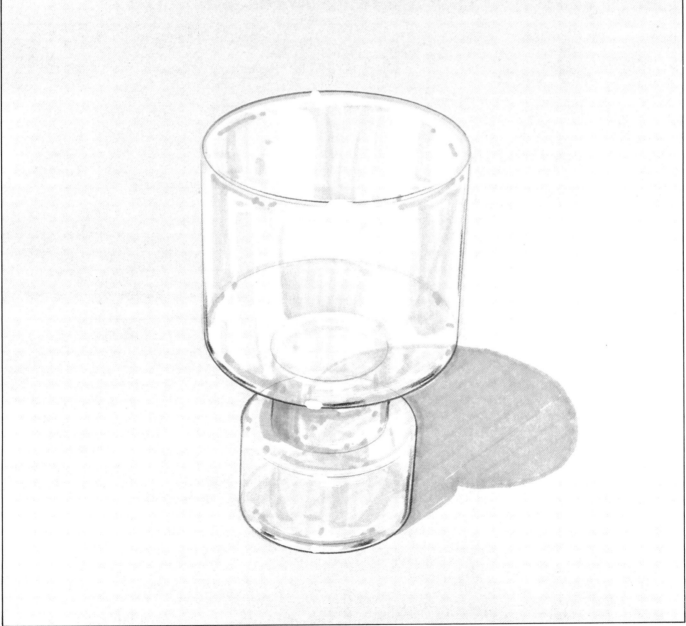

228.

Demonstration: Glass with Liquid Contents

229. The rendering of a glass object and its contents is similar to an empty glass container as far as the overall reflection patterns. The contents are visually distorted somewhat by the glass, and the highlights and reflections on the glass surface obscure part of the contents. After drawing the edges of the glass container with a light gray marker, and then using this same marker to indicate reflected light patterns on the glass surface, I overcoat various areas, again, with the same color marker to develop a value range. At this point the liquid contents are added to the rendering with particular attention given to leaving areas of white space to indicate highlights on the glass surface that visually obscure the liquid.

230. The colored marker has been used to overcoat parts of the liquid area, developing a range of values and defining the shape of the container. A few spots of color have been added as reflections within the wall thickness of the glass container, in this case in the bottom of the vessel. Black colored pencil is then used to define the edges of the glass container. Note that an uncolored area is left between the outside edge of the glass and the liquid contents. This space is very important in that it is the principal visual clue as to the thickness of the glass. The shadow is added to the object with a cool gray #3 marker used outside the object, and the same colored marker used for the liquid is used to overcoat the area defining the shadow through the glass.

231. Highlights have been developed using a white colored pencil. In this case, the white highlights created by not applying marker color are softened with white pencil in order to emphasize the roundness of the container. The addition of farkles completes the rendering. A cut-out piece of white paper was attached behind the rendered glass object to brighten it and enhance the illusion of the transparency of the glass.

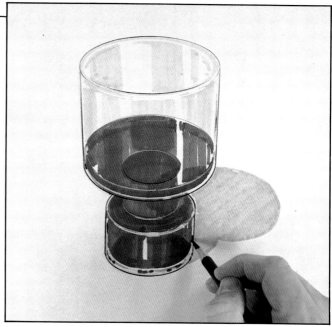

229.

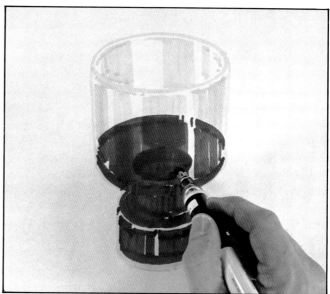

230.

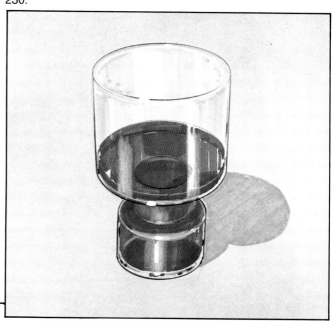

231.

Il vino va anche letto.

Rendering by John Fortune

232.

232, 233. These renderings illustrate how the reflective and transparent qualities of glass can be used. The salt-and-pepper-shaker rendering illustrates the use of reflections on the surface of the glass that are also used to describe the liquid inside. The rendering of the wine glass demonstrates a more romantic application of reflections on glass and in the liquid. They are more subdued and visually soothing than the active, crisp reflections in the salt-and-pepper shakers.

233.

Demonstration: Leather

The principal visual qualities of leather are surface texture (usually soft) and a blended tonal quality. I usually use a very "wet" marker on a highly absorbent paper to simulate leather. This combination of materials results in a blended, soft visual quality that is appropriate for leather.

234. Using the scrub-coat technique of marker application, I apply a solid coat of color. Often, very small areas of white paper remain, which I find enhances the rendering. A line drawing underlay is used as a guide.

235. The baseball, which is also leather, is colored using a gray marker with the scrub-coat application technique; the lacing is added using a yellow ochre marker. By overcoating the gray-and-brown markers, the value ranges of the baseball and the glove are developed.

234.

235.

Fig. 236

236. After using a darker brown marker to develop the shadow areas of the glove, the shadow areas are fully developed with the edge of a dark brown colored pencil. Edges of the glove, ball, and lacing are added with the point of a dark brown colored pencil.

237. Highlight areas of the leather glove are developed using the edge of a white colored pencil. Highlight edges on the lacing and eyelets are added with the tip of the pencil. The stitching of the baseball is added using a fine-tipped red marker.

The completed rendering has the appearance of a well-used leather ball glove. There is a complete range of values and a strong rendition of appropriate surface texture. The writing on the glove was the final touch and was made using a fine-tipped brown marker.

236.

237.

Demonstration: Vegetation

The principal visual qualities of vegetation are the modulation of color throughout a surface and the interplay of light due to the transparency of most types of vegetation.

238. Using an underlay line drawing as a guide, marker is applied to define a blossom. Care is taken to allow a generous amount of white space to remain in order to develop a strong sense of light interacting with the scene. Then, by using a darker color, the value range of the blossom is developed. I use a darker color in this instance because yellow markers tend not to change very dramatically when overcoated.

239. A fine-tipped colored marker is used to develop details such as stamens and petal edges.

240. Other blossoms are colored in a manner similar to the first. The value range of these subsequent blossoms has been developed by overcoating the same color used to first define them.

238.

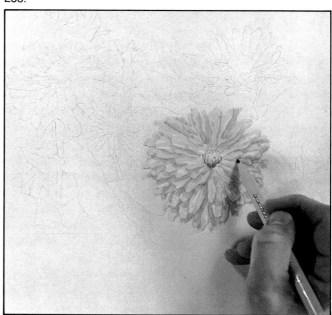

239.

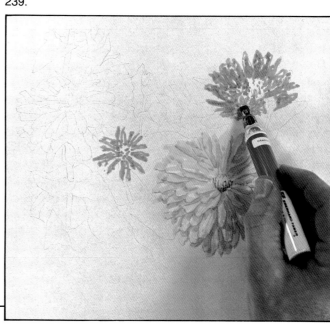

240.

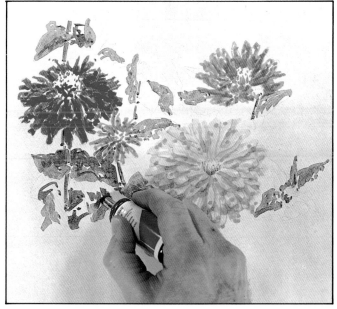

241. Leaves are now added using a green marker. The value range of the leaves, including shadows, is also developed by overcoating.

242. The background is developed in a manner that will highlight the flower blossoms and leaves. Several dark gray markers are used for this purpose. A generous amount of white space is maintained throughout the rendering in order to simulate a sun-dappled scene. The finished rendering has an "Impressionistic" visual quality as a result of this large amount of white space. The full range of values within the flower blossoms and leaves completes the illusion of a living collection of vegetation.

241.

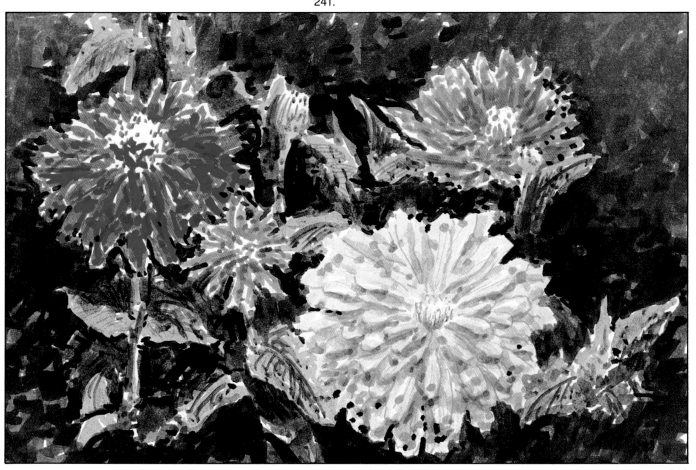

242.

Demonstration: Illustrating Fabric with Rubbed-On Texture

243. The principal visual quality of fabric is texture. In sewn fabric objects, the seams between pieces of fabric are very prominent. I use the scrub-coat technique when rendering fabric. I prefer a highly absorbent paper such as the bond paper used in this example, so that the marker strokes become diffused and the surface color is modulated. By overcoating appropriate areas using the scrub-coat technique, a range of values can be created to alter color or indicate shaded areas.

244. To develop the appropriate texture, I prefer to lay the rendering paper on a rough surface and rub the paper with a colored pencil. In this example, I am using the cover of an encyclopedia volume and a white colored pencil to develop highlight areas.

245. The completed rendering has a range of values and strong textural suggestion. Shadow areas have been developed by rubbing the appropriate areas with a dark colored pencil. The diagonal seam with the detailed stitching in colored pencil completes the illusion of fabric. This method of applying texture is very effective when an appropriate textural source can be located. It's a good idea to experiment with rubbings on your wall, the floor, bricks, wood siding, and other objects. Make a file of texture rubbings for future reference and identify the sources so that you can quickly locate them when needed.

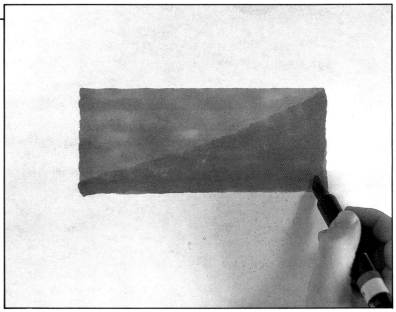

243.

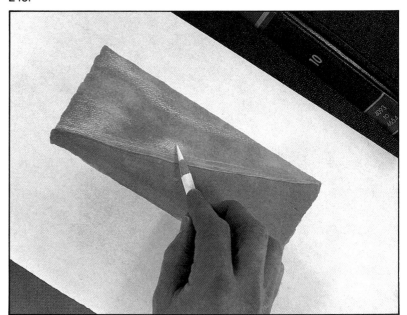

244.

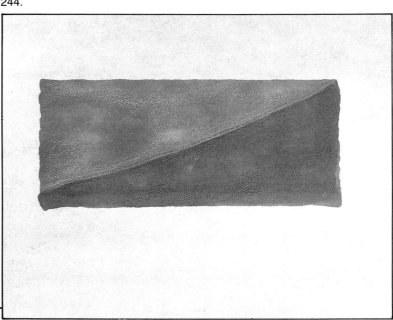

245.

Equipe

246. This rendering of upholstered furniture illustrates the effectiveness of rubbed-on texture in simulating fabric.

Demonstration: Illustrating Fabric with Hand-Drawn Texture

247. If a fabric object has a very coarse or specific textural pattern, it may be most effective to delineate the texture by hand rather than creating a rubbing. After establishing a base coat of color using the scrub-coat application technique, the value range is developed by overcoating appropriate areas.

At this point, texture is developed using a fine-tipped colored marker. It isn't necessary to render the texture over the complete object for an effective visual effect. Often, by texturing only the visually important details of the object, the overall texture of the object becomes evident.

248. Using appropriately colored pencils, the highlights and shadow areas are fully developed with texture.

249. The completed rendering has a strong visual sense of texture as well as a completely developed range of values that make the glove appear extremely three-dimensional. A light gray shadow under the glove completes the three-dimensional illusion.

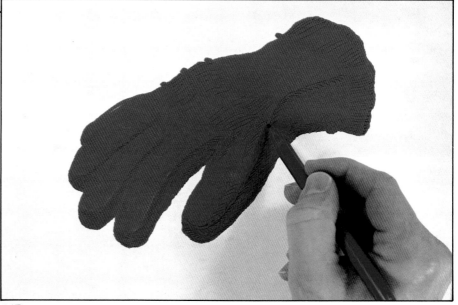
247.

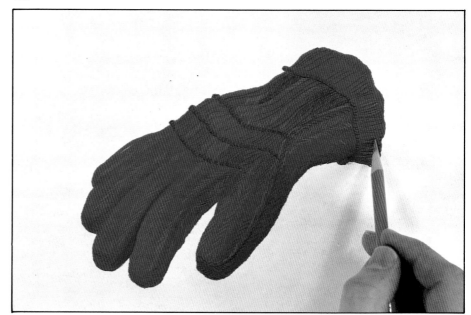
248.

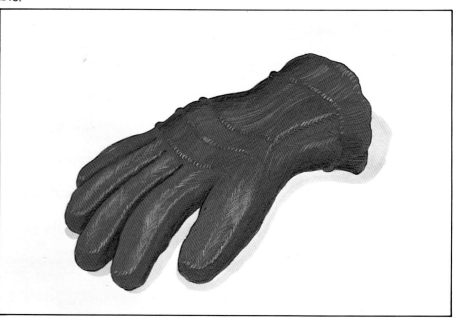
249.

Rendering by Nancy B. Zurbuchen

250. This rendering also uses line to suggest fabric but does so by delineating the flowing qualities of the fabric rather than the texture, which in this case is obviously quite smooth.

CHAPTER 8
BACKGROUNDS AND SPECIAL EFFECTS

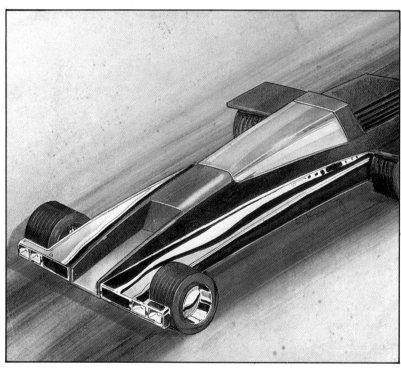

251.

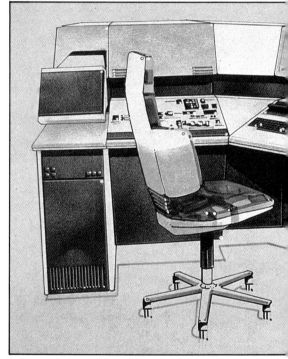

252.

251, 252, 253. The above illustrations are the result of experimentation: they all combine markers with other media. The racing car (figure 251) is set off dramatically by the streaked pastel background. Both figures 252 and 253 employ spray marker for special effects: in figure 252 spray marker was used with frisket film to achieve the subtle value changes found in the dark gray areas of this computer work station; and in figure 253, spray marker was used as a background pattern as well as the middle tone of the wristwatch.

The rendering of an object creates a visual understanding of that object. When a background is added to that object, the visual understanding of it is extended to the environment in which it exists. This extension of visual definition not only increases the degree of information conveyed by the rendering but also makes it more visually exciting and enjoyable to view. A background can be as simple as a shadow on an unidentified surface or as complex as a realistically illustrated environment. Backgrounds can provide information to the viewer about the scale of the object, how it is used, and by whom it is used. A background treatment can be as abstract as a geometric shape or as realistic as a human figure. In some rendering situations there may be little distinction between object and background, especially in those illustrations where a total environment is rendered.

As background techniques become more abstract and experimental, they may often suggest techniques suitable for incorporation into your own work. This chapter describes and illustrates several conventional background techniques and explores several others in which the background becomes an integral part of the object and the distinction between foreground and background becomes less apparent. Several special effects that were created by using supplementary materials and application techniques are also described and demonstrated.

These techniques can also be important in developing a personal marker rendering style. This chapter illustrates several methods of incorporating decorative elements, typography, border treatments, and supplementary notes and views in order to create more informative and interesting rendering presentations.

Rendering by Richardson/Smith Design, Jack Harkins

253.

Rendering by Richardson/Smith Design, Keith Kresge

254.

Realistic Backgrounds

254. The rendering of a total scene such as this example is very effective as an indication of a complete environment. In such a scene, the central focus can often be absorbed and camouflaged by the scene. In this illustration, the viewer's eye has been directed to the center of the scene by fading out the details and marker coloration toward the edges of the rendering. Attention was also directed toward the sign structure by making all of its lines very crisp and mechanical while keeping all other lines very loose and casual.

255. In this example, visual focus on the train car is accomplished by reducing detail in the background scene, including the people standing nearby. Even though the background detail is reduced, the overall appearance is one of realism.

255.

Rendering by Richardson/Smith Design, Tom Hamilton

EMS UNIT
emergency
medical system

Rendering by Sally A Schulz

Abstract Backgrounds

256. An environment can be suggested by developing an abstract composition that captures the visual essence of the scene. This background suggests an appropriate visual "disaster" for the subject matter in the foreground. The background was developed with pastels directly on illustration board. The vehicles and figures in the foreground were rendered separately on marker paper, cut out, and attached to the illustration board after the background was completed.

Suggesting an Environment

257. A complete environment can sometimes be suggested by detailing only a small portion of that environment. This technique is especially successful when dealing with familiar objects and backgrounds such as this automobile. The rendition of a roadway clearly establishes a strong environmental context. Part of the romance and intrigue of this technique is that it allows the viewer to imagine the remainder of the scene in a personal way.

Indicating Scale

258. When rendering scenes and objects that feature unfamiliar subject matter, it is important to indicate scale. This example uses outlines of people to very effectively establish scale as well as a sense of participation in the scene. By keeping the details of the people to a minimum, the focus of the rendering is maintained on the building and its design details.

257.

Rendering by Charles P. Klasen, Klasen Design Associates

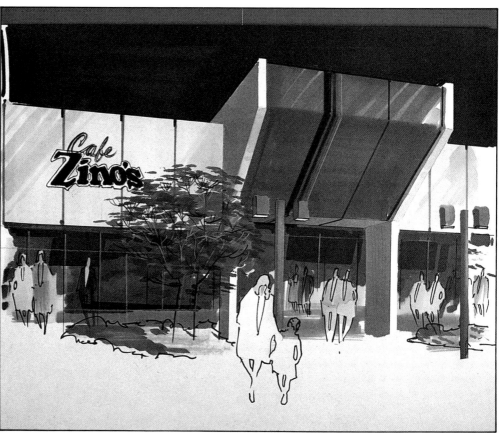

258.

Rendering by Gil Born

Rendering by Ron Hayes

259.

Vignettes

259. An extremely simple yet visually effective method of joining an object to the surrounding ground is to use a simple vignette, or border, that can either surround the object or be situated at the bottom and on one side as in this example. Without suggesting the character of the background, a vignette indicates that there is one and that the object is not floating about in the vacuum of space. Small, simple shadows often serve well as vignettes.

Geometric Backgrounds

260. An environmental background can be established by using a geometric-shaped field of color as indicated by this example. Such a field of color visually stabilizes the image and suggests that it is in a fixed, although unspecified environment. These backgrounds can be created with marker such as this example or cut out of colored paper and attached to the rendering. Note in this example that there is a shadow cast by the object that is clearly visible on the geometric shape. The shape is also reflected in the control panel of this object, which also helps to visually connect the object and the background.

Rendering by Ron Hayes

260.

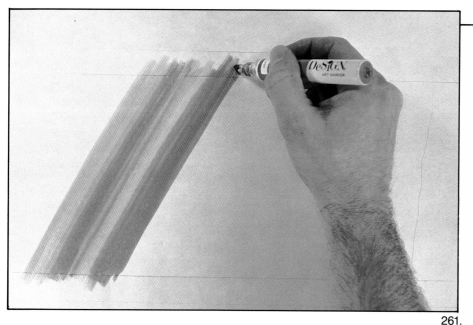

Demonstration: Combining Marker Background and Object

At times, backgrounds can become more interesting and visually important than the object of the rendering. The technique demonstrated here of combining the background and object into one unified visual statement eliminates this problem.

261. The background of the rendering is first developed as demonstrated in this example. Two colors are arbitrarily combined here, but you may prefer to use only one or perhaps many. The angle of the marker strokes in this example was selected to accentuate the form of the object.

261.

262. The shadow areas of a vehicular object are colored on the back side of the paper. By coloring on the back side, the original background colors on the front remain legible and are tinted in a subtle manner. The objective of this technique is to allow the background to merge with the object and become integrated with it visually.

263. Returning to the front side of the paper, dark shadow areas are accentuated with appropriate marker colors. Here the shadows on the wheels are being accentuated with gray marker color.

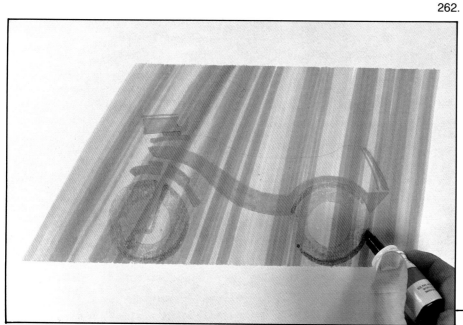

262.

263.

264. Using a dark colored pencil, the lines of the object are defined. Because the value range of the object is not completely developed with this technique, the use of lines to define the object is very important. A sensitive development of a range of appropriate line weights is necessary for an effective illusion of volume.

265. Using the edge of a dark colored pencil tip, the shadows of the object are developed. The transition between shadow area and highlight is rather abrupt so that the background colors remain very readable.

266. The addition of blended highlights with the edge of a white colored pencil tip completes the illusion of volume. While color is suggested in the object, it is the background color and textural pattern that set the tone and is the dominant visual element of the rendering.

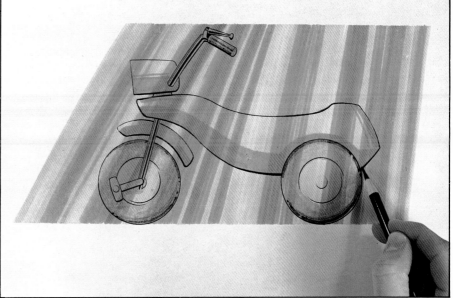

264.

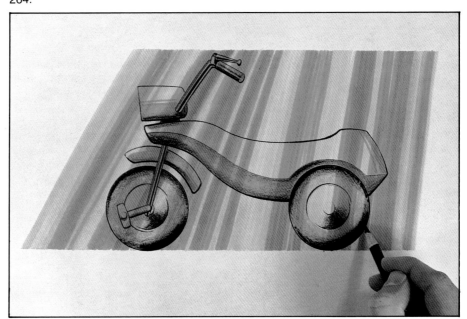

265.

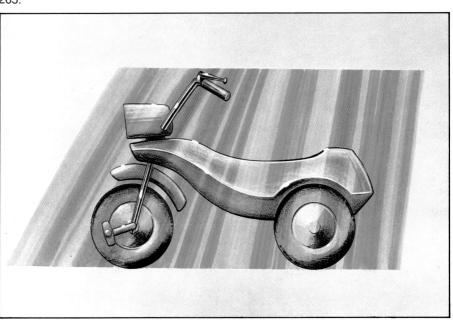

266.

267.

Demonstration: Combining Pastel Background and Object

267. A common technique for pastel drawing is to apply a field of color and then create highlights by erasing portions of the field. This variation of that pastel technique allows the use of marker color as a tool in developing a more complete range of values. Rather than rubbing the pastel onto the paper, carefully shave a small amount of pastel onto the paper, using fine sand-paper or by scraping the pastel with an X-Acto knife as demonstrated here.

268. With a cotton pad or white tissue impregnated with lighter fluid, the pastel shavings are dissolved and spread onto the surface of the paper. The pastel can be evenly distributed and blended to create an evenly toned field of color if desired. In this example I am developing a very linear pattern of pastel with a streakiness that will help accentuate the perspective of the object to be added. The lighter fluid adheres the pastel to the paper in such a way that it doesn't require fixing.

269. Using an underlay line drawing as a guide, highlights are "lifted" from the pastel area with a kneaded rubber eraser. I prefer this type of eraser over a hard gum eraser because it permits very subtle blending of the highlights into medium value areas.

268.

269.

270. The shadow areas of the object are developed on the back side of the paper with a marker color similar to the pastel color used. This marker is applied to the back side of the paper because it would dissolve the pastel coat and cause it to smear.

271. Appropriately colored pencils are applied to the front side of the rendering to define the highlight and shadow edges of the object. Shadow and highlight areas can also be extended by carefully blending colored pencil into the appropriate areas.

272. The completed rendering demonstrates the striking visual effect of combining background and object into a total visual statement. The figure/ground relationship between the two adds to the visual interest of the rendering.

270.

271.

272.

273.

Rendering by John Fortune

Combining Markers and Pastel

273. This rendering of a chair was cut out and applied over an abstract background visual element created by dissolving pastel with lighter fluid. The rhythmic shape of the background helps to move the viewer's eye through the composition.

274. This marker rendering of a leather billfold was cut and applied over a two-color background created with dissolved pastel. The pastel in this example was blended with a very small amount of lighter fluid, which created a strong linear pattern that serves as an effective visual counterpoint to the soft texture of the billfold.

274.

Rendering by Melissa Hogg

275. The backgrounds for the three rendered chickens and the borders of small chickens were created by applying a dissolved pastel solution over a cut-out mask of frisket film. The precise shape of the background squares and the small chickens serve as excellent textural enrichments for this rendering.

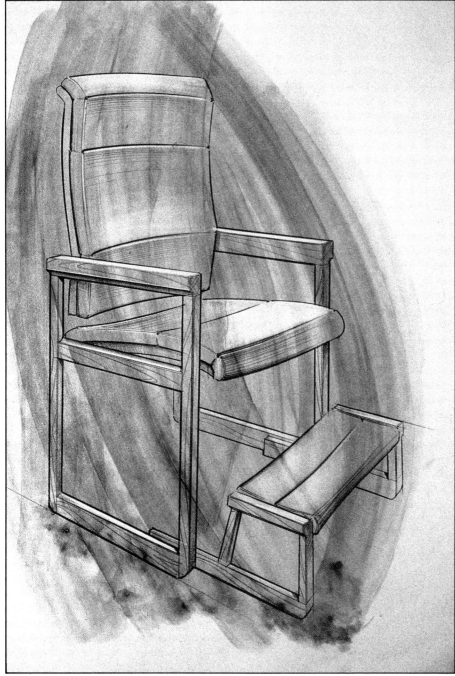

276.

Rendering by Steven M. Montgomery

276, 277. These renderings demonstrate the effectiveness of integrating a dissolved pastel background and the object into a visual whole. Note that the shape and textural pattern of the pastel fields of color are compatible with and enhance the objects. The use of line is much more dominant in figure 276 in defining the form than in figure 277 where the blended rendition of highlights and shadows conveys the essence of the objects' form.

277.

Rendering by Steven M. Montgomery

Masking with Rubber Cement

278. The experimental use of unusual masking materials often leads to unusual
visual effects. In this example, rubber cement applied to the paper with a brush was
used to mask this chair before applying the marker color. A colored paper was used to
achieve a two-colored rendering by using only one marker color. The chair was then cut
out and applied to a white background.

Combining Spray Paints and Markers

279. A product called "Spray Marker" is available that is chemically compatible with markers. Although the odor is pungent, it is fast drying and conveniently applied with a pressurized spray can. Spray marker was used as a background for this rendering. The lettering was created by using transfer lettering as a mask and removing the letters with tape after the spray mark had dried. The textural quality of the spray mark serves as a visual reinforcement of the fabric of the chair.

Rendering by Nancy O'Connell

280. Extensive masking was used to create this rendering of towels. The central square panel was first masked with frisket film, and the blue textural pattern was applied with spray marker. The type was masked using transfer lettering. When that area had dried it was masked with frisket film and the towels were rendered with marker, colored pencils, and pastel. The towels were then masked with frisket film and the purple vignette around the towels was applied.

281, 282, 283. This three-paneled presentation combines marker renderings on paper applied to colored matt board that has been masked and sprayed with an airbrush. The letters in the rule at the bottom of each panel were created by using transfer lettering as a mask. The tonal qualities of the sprayed areas serve to visually unify the three panels and effectively accentuate the marker renderings.

281.

Rendering by Les Kerr

282.

Rendering by Les Kerr

FIBER REINFORCED
ROTATION MOLDED
PLASTIC SPHERE

BEARINGS ARE INSERTED
INTO THE SPHERE
TO FACILITATE EASY
ROTATION.

FOAM RUBBER
PADDING.

FIBER REINFORCED
PLASTIC · INJECTION
MOLDED AS ONE
PIECE

PADDED STRAP
BACKED WITH
VELCRO

REINFORCING ROD
ACTS AS AN AXIS
FOR SPHERE

CIRCLE AID
GYMNASTICS TRAINING TOOL
DESIGN BY LES KERR
1982

Rendering by Les Kerr

283.

INDEX

Rendering by Jonathon Kemnitzer

Edited by Candace Raney
Designed by Brian D. Mercer
Graphic production by Hector Campbell
Text set in 14-point Lubalin Graph Book